IMAGES
of America

JEWISH CHICAGO
A PICTORIAL HISTORY

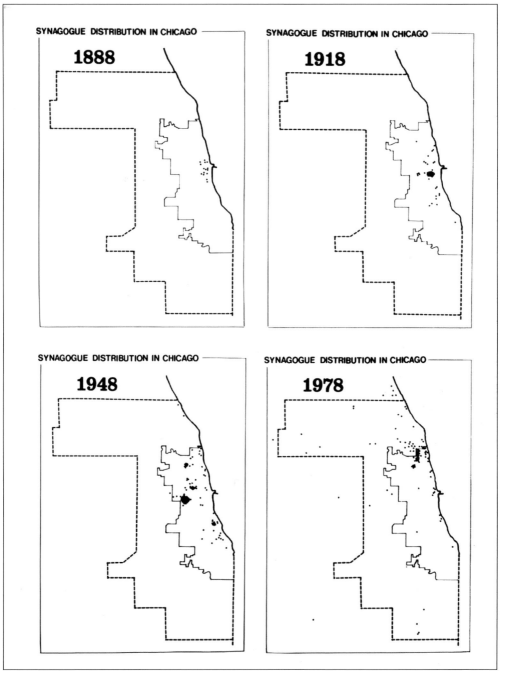

Changes in the distribution of the Jewish population in the Chicago area in almost a century are shown above by the location of synagogues, with each dot representing one synagogue. (Map by Irving Cutler and Joseph Kubal.)

IMAGES
of America

JEWISH CHICAGO
A PICTORIAL HISTORY

Irving Cutler

ARCADIA
PUBLISHING

Published by Arcadia Publishing
Charleston SC, Chicago IL, Portsmouth NH, San Francisco CA

Printed in the United States of America

Library of Congress Catalog Card Number: 00102084

For all general information contact Arcadia Publishing at:
Telephone 843-853-2070
Fax 843-853-0044
E-mail sales@arcadiapublishing.com
For customer service and orders:
Toll-Free 1-888-313-2665

Visit us on the Internet at www.arcadiapublishing.com

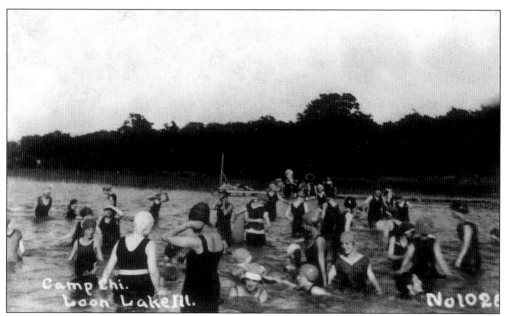

Campers take a swim at Camp Chi (named after Chicago Hebrew Institute), which was located along Loon Lake near Antioch, Illinois, c. 1920s. (Courtesy of the Jewish Federation of Metropolitan Chicago.)

CONTENTS

INTRODUCTION

Jews started coming to Chicago almost at the time of its incorporation in 1833. A century later, with almost 300,000 Jews comprising nine percent of the city's population, Chicago had the third largest Jewish population of any city in the world. They were a diverse group, having come from almost every country in Europe and the Middle East, but especially from Central Europe initially, and later, in much larger numbers, from Eastern European countries.

Their experience in Chicago was somewhat similar to that of other immigrant groups. The first Jews settled in the inner city and created a mixture of religious, cultural, and social service institutions while facing problems of acculturation, fractionalization, and discrimination. Most soon adapted to America, improved economically, and dispersed outward geographically to better areas. But with their long history and distinct religious traditions and values, the Jews were also different. Unlike members of other ethnic groups and despite some sentimental attachments, Jews left the Old Country with no thoughts of ever returning to lands where so many had experienced poverty, discrimination, and even sporadic massacres. America offered freedom and opportunity that they had never experienced before.

The first Jewish settlers in Chicago, mainly from Germany, usually started out as peddlers with sacks on their backs, later opening small stores in what is today's downtown area. By 1847, they had established the city's first synagogue and a Jewish cemetery. They generally got along well with their non-Jewish neighbors and, by 1860, four Jews had been elected to public office. Jews were also moving up in the professions and in business, where they eventually founded companies such as Florsheim; Hart, Schaffner and Marx; Mandel Brothers; Kuppenheimer; Spiegels; Aldens; A.G. Becker; Nelson Morris and Company; Greenbaum Bank; Inland Steel; and the Brunswick Corporation. Following the Chicago Fire of 1871, most of the Jews still largely from Central Europe moved south concentrating in the Grand Boulevard, Washington Park, and eventually in the Kenwood, Hyde Park, and later South Shore communities, establishing throughout these areas many noteworthy Jewish institutions.

Beginning in the late 1870s, Eastern European Jews started coming to Chicago in large numbers. By 1930, they and their descendants made up about eighty percent of the city's Jewish population. They had come mostly from the *shtetls* and smaller cities of Eastern Europe. Having come from a somewhat backward, less educated part of Europe, they differed markedly from the German Jews who had preceded them. The Eastern European Jews were generally much poorer and had a limited secular education, although they were usually well learned in Hebraic studies. They also differed from the German Jews in dress, demeanor, language, and religious beliefs and rituals.

The Eastern European Jews were often upset by the more permissive Reform Judaism which so many of the German Jews had embraced. The German Jews, then living quite comfortably on the South Side, largely Americanized and accepted by the Gentile community, felt that their status would be undermined by the Orthodox "hordes" pouring in from Eastern Europe with their Old Country ways and beliefs. The differences between the German and Eastern European Jews for decades led to a virtual separation of the two groups and the building of duplicate institutions. Nevertheless, the German Jews did help their poorer Eastern European

brethren, who had settled mainly in the poor Maxwell Street area, by building many needed service institutions in the new immigrants' neighborhoods. In time, as the Eastern European Jews worked their way up educationally, economically, and socially, the dichotomy between the two groups largely disappeared.

In the Maxwell Street area, the Eastern European Jews established other institutions including 40 synagogues and a bazaar-like outdoor market that attracted shoppers from much of the metropolitan area. They eeked out a living by peddling, being small merchants, working as artisans, or working in factories, especially in the garment industry where many became active in trade unions.

By 1910, the Eastern European Jews were economically able to start moving out of the crowded Maxwell Street ghetto. A small number joined the German Jews on the South Side, some moved north into communities such as Lakeview, Uptown, Rogers Park, Humboldt Park, Logan Square, and Albany Park. By far, the largest number moved west into the Lawndale area, which became the largest Jewish community in the history of Chicago, both in population and institutional facilities, which included about 60 synagogues. Concurrent with their movement upward and into better neighborhoods was the continued success of Jews in business, various trades, and increasingly in the professions. Frequently, however, Jews had to overcome restrictive provisions and quotas in housing, education, and employment to move ahead.

After World War II, the Jews began to move out of Lawndale and a few other Jewish neighborhoods. Many located in West Rogers Park which today has the densest concentration of Jews within the city, including many who are Orthodox. Others joined the general post-war move to the suburbs where today an estimated seventy percent live, mainly to the north and northwest of the city. Although the Jews of today differ in many ways from their immigrant ancestors, a great many continue to maintain, often in a modified form, much of the culture, values, and traditions of their forebears. While not as primarily dependent on Jewish institutions as before, Jews have built a whole new set of such facilities in the suburbs. And along with supporting Chicagowide philanthropic efforts by contributing time and money to the development of universities, museums, and other institutions, they have also remained committed to the communal tradition of "taking care of their own," at home and abroad.

The story of the Jews of Chicago is that of the blending of a group of people from many lands into a viable, flourishing community that with determination and adaptability, took advantage of the opportunities available to them in a free society. The story includes many contributions to the city and the nation by a number of individuals in the professions, arts, commerce and industry, government service, entertainment and labor including seven Nobel prize winners. Despite some lingering problems, it is a noteworthy success story, although it has not been written without hardship, perseverance, and toil.

The 230 images of Jewish Chicago in this book illuminate aspects of that story from the earliest days to the present.

Irving Cutler
March, 2000

ACKNOWLEDGMENTS

About five years ago, my book *The Jews of Chicago: From Shtetl to Suburb* was published by the University of Illinois Press, and I later learned, through feedback, that a significant part of its appeal was due to its photos. Although limited in number, they evidently brought out nostalgic feelings in many as well as providing an interest in the visual depiction of Chicago Jewish history. This coincided with the interest and excitement aroused by the photos I used in the numerous slide presentations that I have given through the years on the history of Chicago Jewry.

Based on the interest in such photos and the fact that I had hundreds of interesting and meaningful photos that I was not able to use in my book, which was mainly textual, I welcomed the opportunity to produce a book of photos on Jewish Chicago as part of the *Images of America* series by Arcadia. For this book, I assembled additional photos from historical societies, newspapers, libraries, Jewish organizations, and individuals, as well as those that I have taken in subsequent years.

From all these photos, I selected 230 that are presented somewhat chronologically, but mainly topically. This is by no means a definitive account of such a large and varied group of people, and many deserving individuals, institutions, places, and events are not included, but it is hoped that the book provides a vivid snapshot view of the Jews of Chicago.

I would like to thank the following individuals and organizations for supplying photos and otherwise helping in the preparation of this book:

Joy Kingsolver of the Chicago Jewish Archives; The Chicago Historical Society; Jewish Federation of Metropolitan Chicago; Pauline Yearwood and Joseph Aaron of *The Chicago Jewish News*; Mary Ann Bamberger, Special Collections Division of the University of Illinois at Chicago Library; Mary Jo Doyle, Rogers Park/West Ridge Historical Society; Glenn Humphreys of the Ravenswood/Lakeview Historical Association; Mt. Sinai Hospital; Daniel Stuhman, Hebrew Theological College librarian; The American Jewish Historical Society; The Chicago Jewish Historical Society; various members of the Harold Washington Library and the Conrad Sulzer Regional Library of the Chicago Public Library; photographer Debra M. Greenberg; Chicago Sinai Congregation; The University of Chicago; The Hyman Meites Family; Dr. Julius Wineberg; Sid Sorkin; Sheldon Robinson; Irwin Lapping; Mildred Wittenberg Mallin; Jerome Robinson; David Rosen; Arthur Schimmel; Seymour Gabel; Sid Bass; Marc Shulman; Zan Skolnick; Rose Pollack; Jan Schurgin; Dorothy Yashon; Bella Joseph; and Margo Solomon.

Special thanks go to Dr. Irwin Suloway, who gave valuable suggestions and constructive criticism during the preparation of the book, as well as reviewing and appraising the final version. My niece Leah Wexler, daughter Susie and her husband Joab Silverglade, and son Dan for their help with the evaluation of the photos and text. Finally, I would like to thank my wife, Marian, for her constant help, good advice, and encouragement in bringing this book to completion.

One

FROM DOWNTOWN SOUTHWARD

The movement southward from downtown is mainly the story of the German Jews from Central Europe. The first permanent Jewish settlers in Chicago came from Germany in 1841. Life in Germany for them was fraught with restrictions, discrimination, and sometimes outright persecution, even though they had lived there for more than a millennium. In Chicago they initially lived in the downtown area, generally earning a living as small retailers. After the fire of 1871 and with economic improvement as they moved up in commerce, industry, and the professions, they started moving mainly southward into attractive neighborhoods ever further from downtown. Eventually they were joined in these communities by increasing numbers of Eastern European Jews.

This chapter will deal mainly with the German Jews of the South Side, the dominant Jewish group in Chicago by way of power and wealth, as well as major organizations and institutions into the early years of the 20th century.

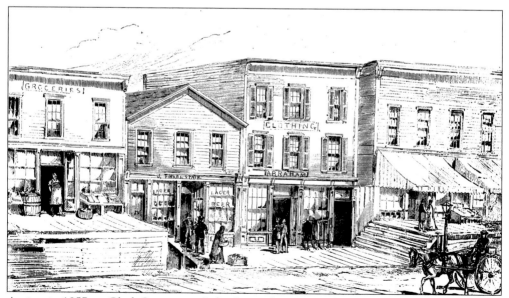

A view in 1857 on Clark Street near Lake Street shows a number of Jewish owned stores. This is the area where the first Jews in Chicago settled. The Jews usually lived behind or above their stores. (Courtesy Chicago Historical Society.)

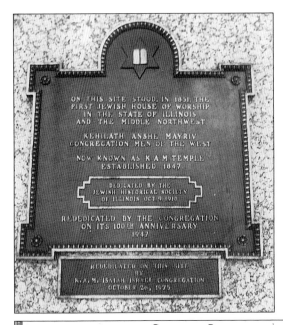

This historical marker is on the Kluczynski Federal Building at Clark Street, near Jackson Boulevard, at the location of Chicago's first synagogue, Kehilath Anshe Mayriv. (Photo by Dr. Julius Wineberg.)

Many Chicago Jews served in the Union Army in the Civil War. Company C of the 82nd Illinois Regiment (Concordia Guards) was an all Jewish group of volunteers who participated in the battles of Fredericksburg, Chancellorsville, Gettysburg, and Chattanooga. Other soldiers included the architect Dankmar Adler, who was wounded at Chickamauga, and Marcus Spiegel who, with his brother, had planned to open a store that eventually became Spiegels. Marcus was killed in battle just prior to his promotion to brigadier general. (From Meites, ed., *History of the Jews in Chicago.*)

CHICAGO JEWS IN THE CIVIL WAR

82ND ILLINOIS REGIMENT, COMPANY C

CHARLES BREDE
HERMAN BURGHEIM
FRIEDRICH COHN
MORITZ FRANK
MAYER FRANK (Lieutenant, and later successor to Captain La Salle as Captain of the Company)
ALEXANDER HENSHALL
JACOB HERRMAN

LEOPOLD HESSBERGER
JACOB HEYMAN
LEOPOLD HIRSCHLEIN
L. HIRSCH
ISIDORE HESSLEIN
SAMUEL KRAMER
WILLIAM LOEB (promoted from private to 2nd Lieutenant, and later Captain)
LOUIS LEVY
JACOB LAMMFROMM

NATHAN MARKS
DANIEL MEIER
PHILIP MEIER
E. MANNHEIM
GODFREY MANN MANHEIMER
ABRAHAM SALOMON
GUSTAV SIMON
SIEGMUND SIESEL
MOSES WOLF
LOUIS ZAELLNER

OTHER COMPANIES OF 82ND ILLINOIS

GEORGE BAUM, Sergeant, Co. 3
JACOB BAUER, Co. H
LOUIS BLUM
JACOB BRAND
HENRY COHEN, Co. K
I. FRANK, Co. A
JOSEPH GOTTLOB (Lieutenant, and later Captain of Co. I)

A. JACOBSON, Co. I
HERMAN KOCH, Sergeant, Co. F
FRANK KOCH, Co. F
GUSTAV KOCH, Co. H
GOTTLIEB MEIER, Co. D
WILLIAM MAYER, Co. D
JACOB MEIER, Corporal, Co. K
DAVID MEYERS, Co. I
MORITZ NIEMAN, Co. A

SAMPSON ROSENTHAL
FRANK SOMMER, Corporal, Co. B
JOSEPH M. STEINBACH
HERMAN SIMPSON, Corporal
FRANK SHOENWALT, Lieutenant, Co. K
ABRAHAM WURZBURGER, Co. A
JOSEPH WEISS, Co. H

12TH ILLINOIS REGIMENT

JOSEPH B. GREENHUT (later Captain of 82nd Illinois)
WILLIAM HEINEMAN (killed at Fort Donelson)

JAMES JACOBS
AARON ARNOLD, Co. B.
HENRY DAVIDSON (died of wounds)
PHILIP FRANK
FRANK JACOBSON

EDWARD KOHN, Co. H
CHARLES MAYER, Co. G
HERMAN MEYERS
M. P. WOLF, Co. G

24TH ILLINOIS REGIMENT

EDWARD S. SALOMON (later Brigadier General)
MORITZ KAUFMAN (Corporal, later 1st Lieutenant, Co. H)
FERDINAND OCHS
ELIAS SUMMERFIELD
CAPTAIN GEORGE EISENSTEIN, Co. K.
ISIDORE BLUMENTHAL, Corporal, Co. K
EDWARD BLUMENTHAL, Co. K

ALEXANDER BAMBERGER, Co. K
MAX ERLACHER, Co. B
ABRAHAM GOLDSMITH
HENRY KOHN
JACOB KAUFMAN, Co. K
JOSEPH LEVY, Co. A
A. MAYER, Sergeant, Co. A
CHARLES MAYER, Corporal, Co. F
ISIDORE MEIER, Co. K

(Corporal Mayer and Isidore Meier were captured, and died in Andersonville Prison)
G. M. NATHAN, Co. B
MORRIS NATHAN
JULIUS OPPERMAN
JOSEPH SIMON, Co. G
ADAM SIMON, Corporal
CHARLES WOLF

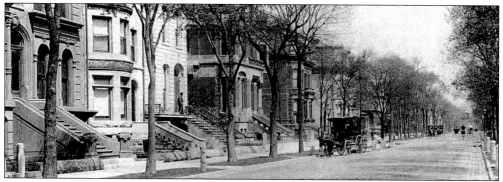

Looking northward on Prairie Avenue in 1892 from 22nd Street (Cermak Road), an area where a few affluent German Jews lived among the Chicago elite. (Courtesy Chicago Historical Society.)

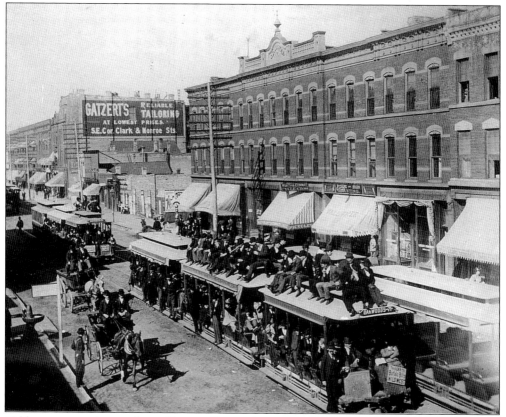

Cable cars are going south on Cottage Grove Avenue in the Grand Boulevard area enroute to the World's Columbian Exposition, October 8, 1893, a free day. The area contained a growing German-Jewish population, especially after the coming of the South Side elevated system. Gatzert, whose advertisement is in the background, was a president of the South Side Sinai Congregation.

Dr. Emil G. Hirsch (1852–1923) was the nationally known Reform rabbi of Sinai Congregation from 1880 until his death. He innovated numerous changes in his congregation. His many activities included being president of the Chicago Rabbinical Association and of the Chicago Library Board, editing the *Reform Advocate*, promoting vocational education, arbitrating labor disputes, and being one of the original faculty members of the University of Chicago. He fought for social reforms, assisted Eastern European immigrants , and helped establish the Jewish Training School and the Chicago Hebrew Institute. (Courtesy Sinai Congregation.)

This program, in a way, reflected the growing Americanization and assimilation of the German Jews. Dr. Sigmund Zeisler, a noted Jewish attorney, was an authority on the life of Lincoln. The choir was largely Gentile. The Sinai Congregation was at the site indicated from 1876 to 1912. The interior of the sanctuary was designed by Dankmar Adler and Louis Sullivan. (Courtesy Sinai Congregation.)

SINAI CONGREGATION

INDIANA AVENUE AND TWENTY-FIRST STREET
CHICAGO

Sunday Morning, February 14, 1909, at 10:30 o'clock.

SERVICE

In honor of the 100th Anniversary

OF THE BIRTH OF

ABRAHAM LINCOLN

Born February 12, 1809. Died April 15, 1865.

Dr. Emil G. Hirsch and Dr. Sigmund Zeisler

WILL DELIVER ADDRESSES

THE CHOIR

Mrs. Mabel Sharp Herdien ⎱ *Sopranos.*	Mr. W. B. Ross ⎱ *Tenors*	
Mrs. Arthur Dunham ⎰	Mr. Glenn Hobbs ⎰	
Miss Leontine Myers	Mr. E. F. Waite	
Mrs. Rose Luttger Gannon ⎱ *Altos.*	Mr. Albert Borroff ⎱ *Basses*	
Miss Lucy Hartman ⎰	Mr. Guy C. Shaw ⎰	
Miss Zoe Ulrich	Mr. F. G. Vary	

ALBERT BORROFF, *Cantor*

ARTHUR DUNHAM, F. A. G. O., *Organist and Director of the Music*

This is Augusta Rosenwald's 73rd birthday at the home of Mr. & Mrs. Julius Rosenwald at 4901 S. Ellis Avenue in 1906. Her son, Julius Rosenwald (fourth from left, back row), was president and chairman of the board at Sears Roebuck and Company. A major philanthropist, he was very active and supportive of numerous Jewish and non-Jewish causes and organizations throughout the country, serving as president of Jewish Charities of Chicago, the Chicago Hebrew Institute, and the Jewish Historical Society of Illinois. He also founded the Museum of Science and Industry. (Courtesy Chicago Jewish Archives.)

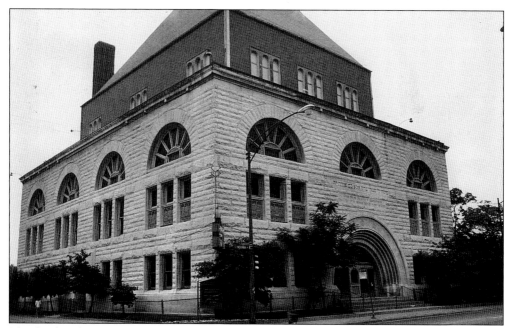

The landmark Kehilath Anshe Maariv (KAM) sanctuary at 33rd and Indiana Avenue was designed by Louis Sullivan and Dankmar Adler (son of the congregation's Rabbi Liebman Adler). Completed in 1891 at a cost of $110,000, this building is now the Pilgrim Baptist Church. In 1920, as the neighborhood changed, KAM moved to 50th Street and Drexel Boulevard in the Hyde Park-Kenwood area (now the headquarters of Jessie Jackson's Operation Push). (Photo by Irving Cutler.)

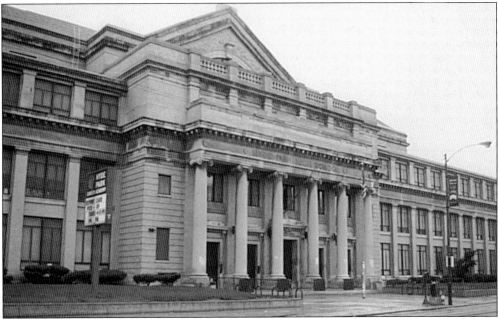

Jewish students living in Hyde Park and neighboring areas mainly attended the academically highly rated Hyde Park High School at 6220 Stony Island Avenue, opposite Jackson Park. A smaller number attended the University of Chicago High School. (Photo by Irving Cutler.)

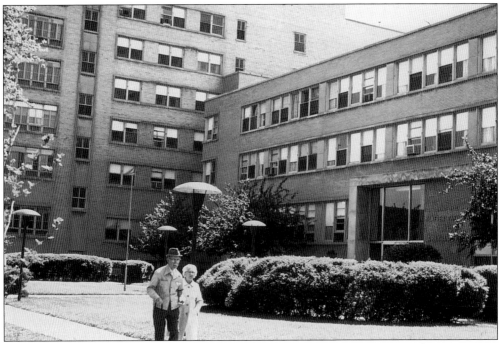

The Drexel Home for the Aged, at 62nd Street and Drexel Avenue, opened in 1893 as a residence primarily for German Jews. It closed in 1981, with most of its residents transferring to the new Lieberman Geriatric Health Centre in Skokie. At the time of Drexel's closing, the average age of its occupants was 87. (Photo by Irving Cutler.)

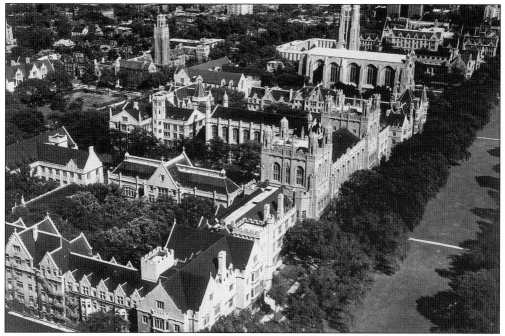

This is a view of part of the University of Chicago looking northeast from 59th Street and Ellis Avenue in 1965. Aid by Jews goes back to its founding in 1892, when its opening was threatened by financial difficulties until the Standard Club contributed $28,350 raised from its members. Through the years, Jews who have made major financial contributions to the university included Mandel, Rosenwald, Pick, Crown, Rubloff, Kersten, Klutznick, Epstein, Pritzker, Goldblatt, Regenstein, Cummings, Mitchell, and Kuppenheimer. An estimated 20 to 25 percent of the students and faculty are Jewish. (Courtesy of the University of Chicago.)

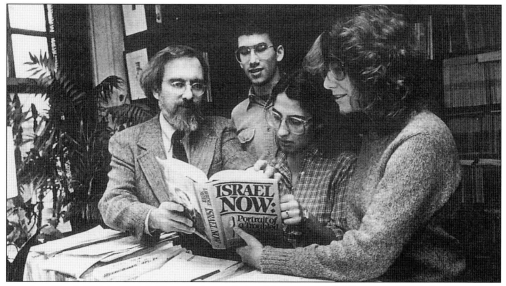

At the B'nai B'rith Hillel Foundation of the University of Chicago, 5715 S. Woodlawn Avenue, Rabbi Daniel Leifer spearheaded events such as Talmud study groups, minyans, Shabbat dinners, cultural programs, and informal discussions from 1964 to 1996.

This was the home of Bobby Franks at Hyde Park Boulevard and Ellis Avenue. In 1924, Bobby Franks, 14, was murdered by two University of Chicago graduate students, sons of prominent neighboring families who wanted to commit the perfect crime. Nathan Leopold and Richard Loeb were spared the death penalty through the skillful defense of their attorney, Clarence Darrow, in what was one of the most publicized trials in the 20th century. (Photo by Dr. Julius Wineberg.)

Woodlawn Avenue near 49th Street, looking west. Kenwood was an affluent area where many German Jews lived for much of the first half of the 20th century. The house in the center was later owned by Mohammed Ali, the champion boxer. Today, a block to the north, are the homes of Louis Farrakhan and of several of the sons of Elijah Mohammed. (Courtesy Chicago Jewish Archives.)

In Hyde Park c. 1930, many German Jews lived in these residential apartment hotels and apartment buildings near Jackson Park. On the left is the Flamingo Hotel, and on the right the Shoreland Hotel. (Courtesy Special Collections, Chicago Public Library.)

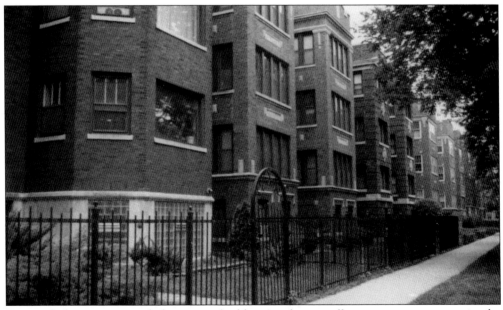

Depicted above are typical three-story buildings with generally spacious apartments in the South Shore area south of Jackson Park. Jews started moving into South Shore in large numbers after World War I and by the 1950s, there were about 20,000. Eventually, the Eastern European Jews outnumbered the German Jews there. Before its decline as a Jewish neighborhood in the 1960s there were about a dozen synagogues divided among Reform, Conservative, and Orthodox. (Photo by Irving Cutler.)

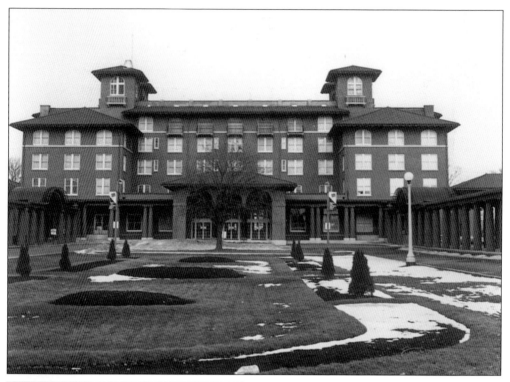

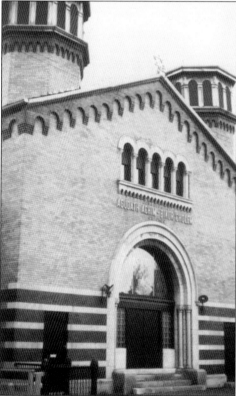

The South Shore Country Club at 71st Street and South Shore Drive, with its private beach, was adjacent to major Jewish neighborhoods, but excluded Jewish members. Today it is operated by the Chicago Park District and is open to all. (Photo by Dr. Julius Wineberg.)

Agudath Achim Bikur Cholem, at 8927 South Houston Avenue in the South Side steel mill area, has the distinction of being the oldest continuously used synagogue building in the city. Completed in 1902, it served a small South Chicago Jewish community. As the neighborhood changed to become largely Hispanic, synagogue membership declined, and in recent years the building has been used as a synagogue by Black Hebrews. It is one of the few synagogues left of the several dozen formerly on the city's South Side. (Photo by Irving Cutler.)

Two

MAXWELL STREET

The Maxwell Street area, in the vicinity of Roosevelt Road and Halsted Street, was the most densely populated Jewish community in Chicago between the years 1880 to 1920. It was a community of Eastern European Jews coming mostly from *shtetls* (small rural villages or towns inhabited primarily by Jews) mainly under Russian rule. In these villages they had lived in poverty, under numerous restrictions and periodic pogroms. When they could, they fled that backward autocracy and came to the "golden land:" America. Most landed on the east coast and remained there, but large numbers made it to booming Chicago. They moved into the Maxwell Street area, which had already been abandoned by the Germans and the Irish. There, in a densely populated ghetto where they recreated a type of *shtetl* atmosphere, they barely earned a living, working their way up and out. This area produced an unusual number of prominent Jewish people, including musician Benny Goodman, US Supreme Court Justice Arthur Goldberg, Admiral Hyman Rickover, CBS founder William Paley, author Meyer Levin, community organizer Saul Alinsky, political power Jacob Arvey, Paramount Pictures president Barney Balaban, Oscar winner Paul Muni, and Federal Judge Abraham Lincoln Marovitz. As a tough neighborhood, it also produced world champion prize fighters Jackie Fields and Barney Ross, as well as the gangster Jake "Greasy Thumbs" Guzik.

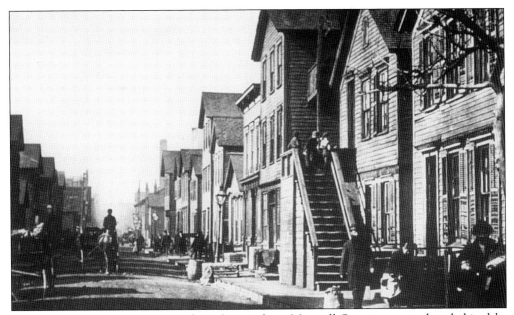

This 1906 view of a typical, residential area along Maxwell Street was mostly inhabited by Eastern European Jewish immigrants. (Courtesy Chicago Historical Society.)

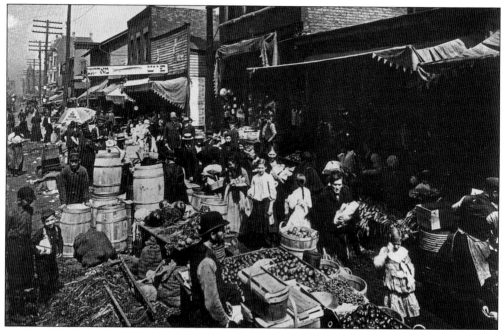

The Maxwell Street market was known for its new and used merchandise, as well as its bargaining, seen here in 1905. It stretched for over a half mile and at one time ranked third as a retail area in the city. The Yiddish sign in the background reads "Fish Market." (Courtesy Chicago Historical Society.)

Anything could be sold on Maxwell Street. Besides basic clothing, food, and household goods, one could also buy rusty nails, coffins, used spectacles, bicycle parts, jinx-removing incense, and even used toothbrushes.

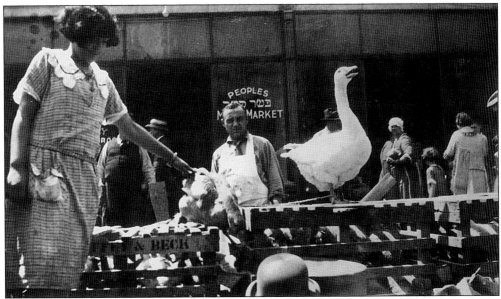

Live geese and other fowl were also for sale on Maxwell Street, seen here around 1920. When bought, the fowl would be ritually slaughtered. (Courtesy Special Collections at the University of Illinois at Chicago Library.)

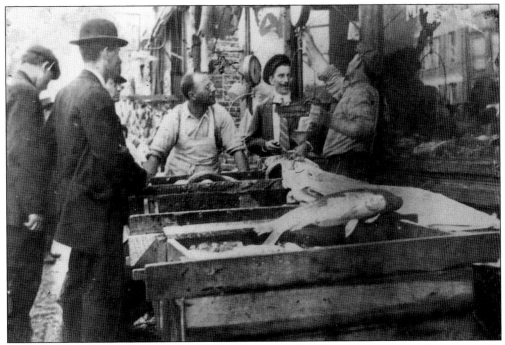

Pictured above is the Maxwell Street fish market, c. 1920. (Courtesy Special Collections at the University of Illinois at Chicago Library.)

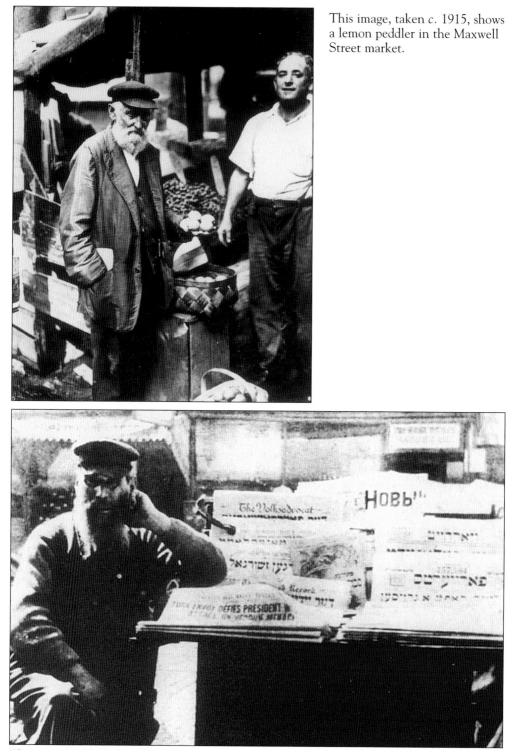

This image, taken *c.* 1915, shows a lemon peddler in the Maxwell Street market.

There are five Yiddish papers—one socialist, one communist, and three orthodox—among the variety of foreign language papers at this Maxwell Street newsstand, *c.* 1925.

In the doorway of the Wittenberg Matzoh Company at 1326 S. Jefferson in the Maxwell Street area, are Wittenberg family members themselves, c. 1919. (Courtesy of Mildred Wittenberg Mallin.)

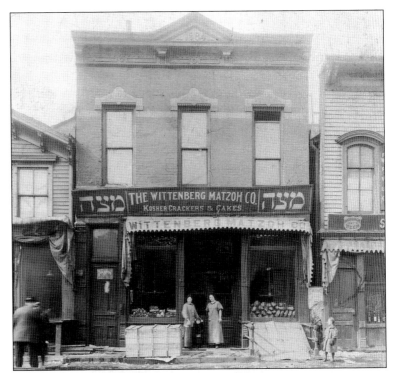

Packing matzoh for Passover at the Wittenberg Matzoh Company, 1937. (Courtesy of Mildred Wittenberg Mallin.)

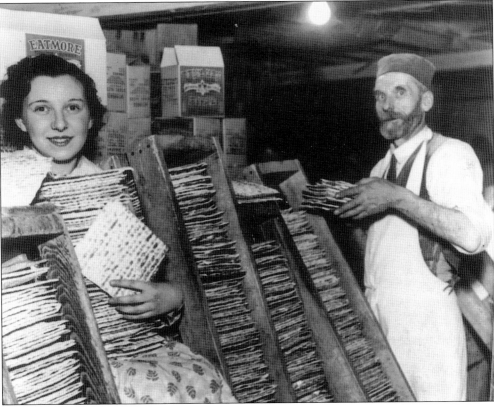

In the center of this *c.* 1940 photo is Joseph Robinson, owner of Robinson's Department Store at 657 Maxwell Street. The store carried a wide variety of merchandise and was the largest seller of expensive mahjongg sets in the city. Robinson's was always closed on Saturdays and Jewish holidays. The store employed about 50 people. (Courtesy of Sheldon Robinson.)

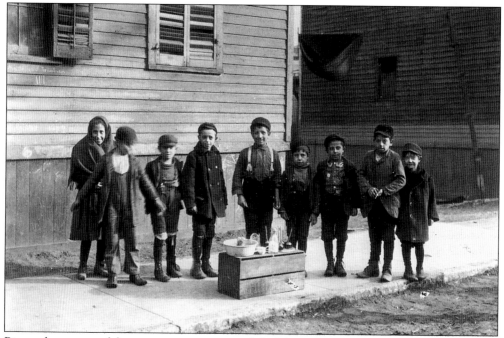

Pictured are some of the young entrepreneurs of the Maxwell Street area, *c.* 1900. (Courtesy of Chicago Historical Society.)

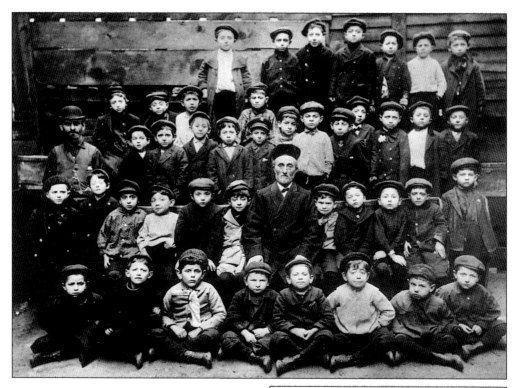

A *Cheder* (Hebrew Elementary school) that was located in the Maxwell Street area near De Koven and Jefferson Streets, *c.* 1906.

The Jewish Training School, one of the first vocational schools in the country, was opened in 1891 at 12th Place near Clinton Street. It was funded mainly by German Jews, probably in an effort to speed up the Americanization of the Eastern European Jews and teach boys and girls useful skills. After serving thousands of students well, it closed in 1921 after many of the Jews had left the area. Its graduates included the Zionist leader Max Shulman, Alderman Jacob Arvey, Federal Judge Abraham Lincoln Marovitz, and many successful business people.

SOUVENIR PROGRAM

Alumni Reunion

JEWISH TRAINING SCHOOL

72ND YEAR — 1891 -1963

Morrison Hotel

SATURDAY, OCTOBER 26, 1963

The Medill elementary evening school graduation class of 1926 was composed largely of recent adult Eastern European Jewish immigrants. The school was located at 1326 W. 14th Place in the Maxwell Street area. (Courtesy of Rose Pollack.)

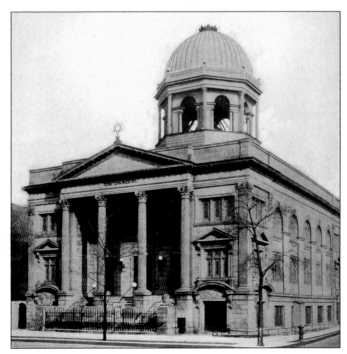

Probably the most architecturally notable of the 40 synagogues in the Maxwell Street area was the Anshe Sholom Synagogue at Polk Street and Ashland Boulevard. Built in 1910, it served its members until 1926, when it became a Greek church. The congregation followed its members to Lawndale (Polk Street and Independence Boulevard) and now is at 540 W. Melrose Street as Anshe Sholom B'nai Israel. Its rabbi, for a number of years, was Rabbi Saul Silber. (From Meites.)

On the fringe of the Maxwell Street area at 19th and Ashland was the area's only Reform congregation: Temple B'nai Jehoshua, the last surviving synagogue in the area, closing in 1965. It was founded by Bohemian Jews in 1893 and is now located in Glenview as B'nai Jehoshua Beth Elohim. Its present Rabbi, Mark Shapiro, also officiated at the Ashland Avenue sanctuary. (Photo by Irving Cutler.)

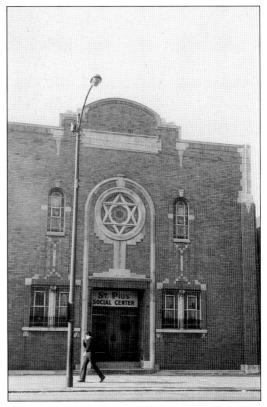

The photo below pictures boys in boxing poses at the Chicago Hebrew Institute at Taylor Street and Lytle Avenue, c. 1915. The Chicago Hebrew Institute opened in 1908. It provided a wide range of educational, social, and physical education programs for both the young and adults. In 1926, it moved into Lawndale as the Jewish Peoples Institute. (Courtesy Chicago Historical Society.)

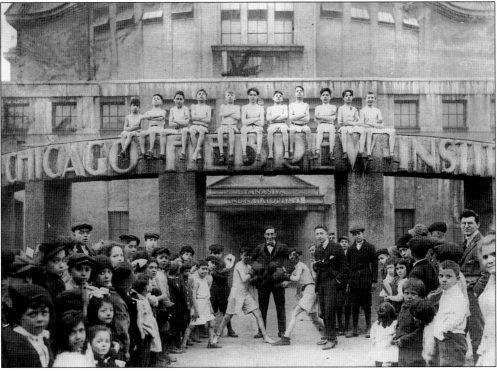

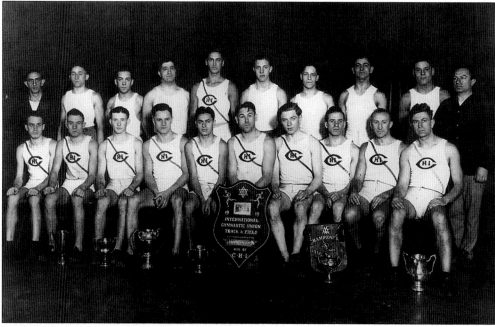

Pictured above is the 1919 Chicago Hebrew Institute's winning track and field team. (Courtesy Jewish Federation of Metropolitan Chicago.)

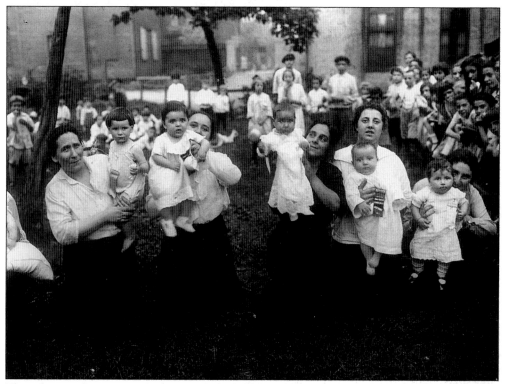

This photo, taken in 1915, shows a baby beauty contest at the Chicago Hebrew Institute. (Courtesy Federation of Metropolitan Chicago.)

Heavyweight boxing contender "Kingfish" Levinsky grew up in the Maxwell Street area, where his parents had an outdoor fish stand. He fought such champions as Jack Dempsey and Joe Louis. With him is his sister Lena, his manager.

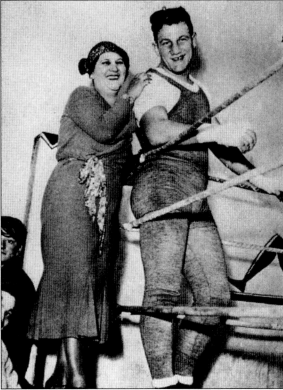

Jake "Greasy Thumb" Guzik grew up in the Maxwell Street area, later becoming Al Capone's bookkeeper.

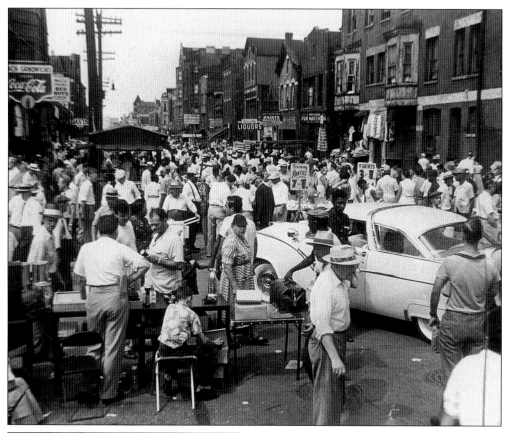

When this photo was taken in 1955, there were still many Jewish merchants; however, in the ensuing years, they began to leave Maxwell Street, especially after the riotous period of 1968. (Courtesy of Seymour Gabel.)

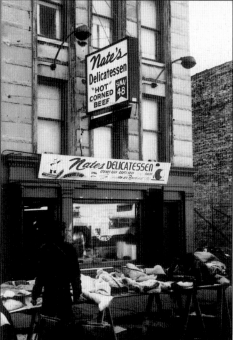

Until it was recently demolished, Nate's Delicatessen (formerly Lyons) on Maxwell Street near Halsted Street was owned by Nate Duncan, an African American who worked for Lyons for many years, where he learned to speak Yiddish and cook kosher style. (Photo by Irving Cutler.)

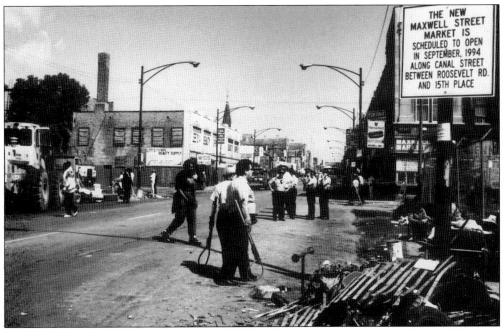

Much of what was left of Maxwell Street was torn down by the city in 1994 despite strong opposition from vendors, customers, and local historians and conservationists. The land was then turned over to the adjacent University of Illinois at Chicago for future expansion. The city, however, did allow for a Sunday only Maxwell Street-style market a half mile to the east on Canal Street. (Photo by Irving Cutler.)

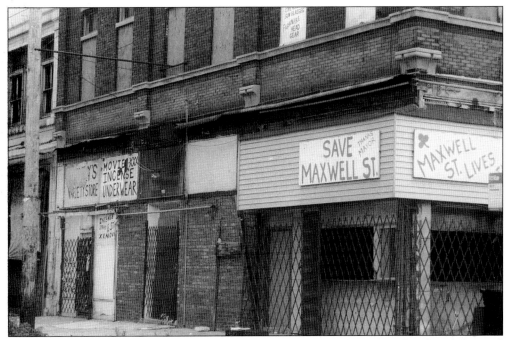

Signs indicate an ongoing effort to save some of the historic district of an abandoned Maxwell Street near Halsted Street, 1999. (Photo by Irving Cutler.)

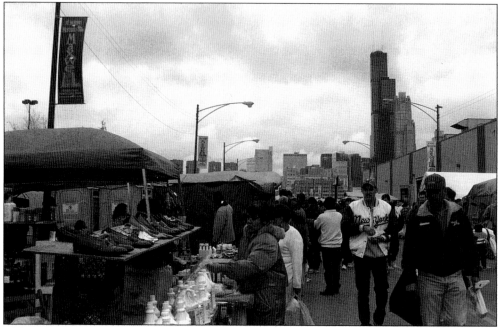

Although the new "Sunday only" Maxwell Street market on Canal Street between Taylor and 15th Streets is still very busy, the modern version lacks the history, the flavor, and the smells of the old Maxwell Street market, as well as the Jewish presence. (Photo by Irving Cutler.)

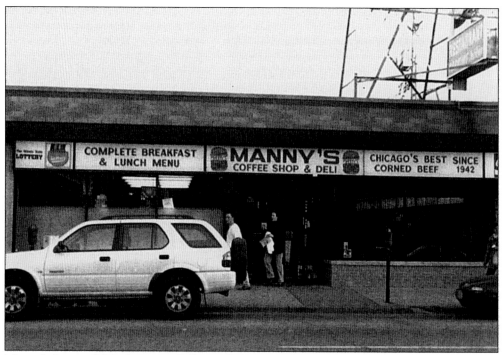

Manny's famous deli/cafeteria on Jefferson Street near Roosevelt Road has been located in the Maxwell Street area for more than half a century and is now run by the third generation of the Raskin family. (Photo by Irving Cutler.)

Three

THE GREATER
LAWNDALE AREA

Around 1910, the Jews started moving into the pleasant, attractive community of Lawndale on the city's West Side. By 1940, it contained about 110,000 Jews—nearly forty percent of the metropolitan area's Jewish population. Most were of Eastern European descent and Orthodox Jews who previously lived in the Maxwell area. In Lawndale they built the largest Jewish community that Chicago ever had, with some 60 synagogues and numerous ancillary institutions. They endowed the area with a *Yiddishkeit*, which has never been duplicated in Chicago. Roosevelt Road was the main commercial street, while Douglas and Independence Boulevards were wide parkways lined with good residential facilities and a number of Jewish institutions.

The Jews lived in the Greater Lawndale area for some 40 years, when a mass exodus began. The exodus was based on improvement in their economic status, racial change, and perceptions of better amenities in the newer parts of the city and suburbs, where there was the hope of an attractive home of one's own; all facilitated by the availability of low-cost insured loans.

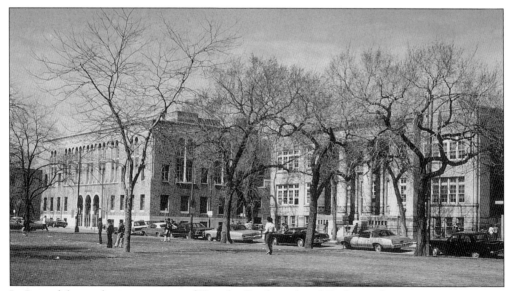

In Lawndale, at the intersection of Douglas Boulevard and St. Louis Avenue were two major Jewish institutions. The Hebrew Theological College (right) was there from 1922 to 1956, attracting students from many lands. It now occupies a 16-acre site in Skokie. The Jewish People's Institute (left), there from 1926 to 1955, was a very busy and important cultural, educational, social, and recreational center with a wide range of facilities and activities that attracted thousands of people each week. (Photo by Irving Cutler.)

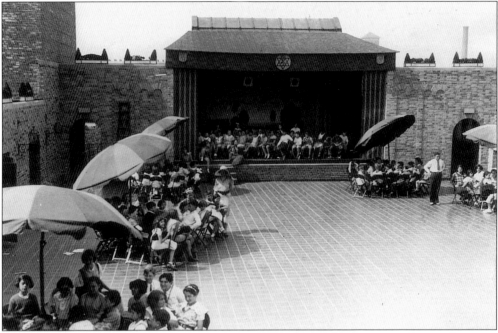

The roof garden of the Jewish People's Institute was used in the warmer months as a day camp for a variety of educational, social, and community events, as well as the site of the very popular Sunday evening dances, where dozens of marriage matches began. The JPI, as it was called, was the successor to the Chicago Hebrew Institute of the Maxwell Street area. (Courtesy of the Chicago Historical Society.)

Choir rehearsal held at the Jewish People's Institute, c. 1940. The JPI served people of all ages. (Courtesy of the Jewish Federation of Metropolitan Chicago.)

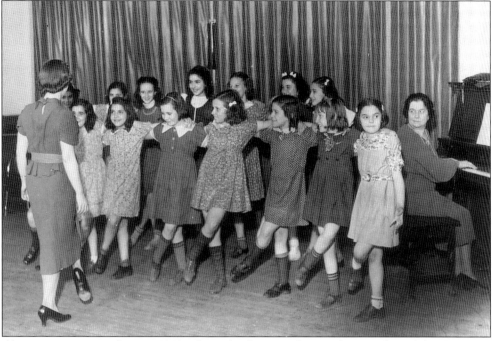

Above is a picture taken *c*. 1940 of a girls' dancing class at the Jewish People's Institute. (Courtesy of the Jewish Federation of Metropolitan Chicago.)

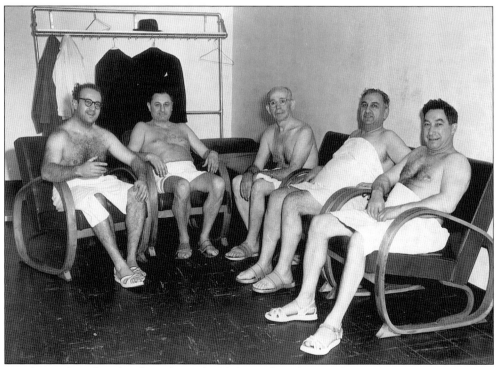

Members relax after the *shvitz* (steambath) located at the Jewish People's Institute, *c*. 1940. (Courtesy of the Chicago Historical Society.)

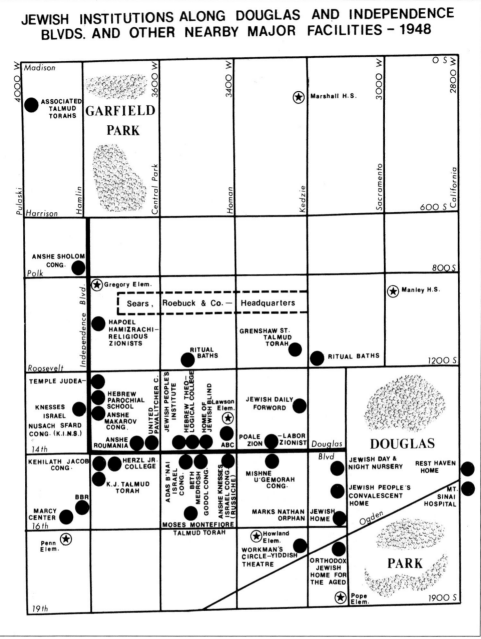

JEWISH INSTITUTIONS ALONG DOUGLAS AND INDEPENDENCE BLVDS. AND OTHER NEARBY MAJOR FACILITIES – 1948

Madison

4000 W

ASSOCIATED TALMUD TORAHS

GARFIELD PARK

3600 W

3400 W

Marshall H.S.

3000 W

O S

2800 W

Pulaski

Hamlin

Central Park

Homan

Kedzie

Sacramento

California

Harrison

600 S

ANSHE SHOLOM CONG.

Polk

Independence Blvd.

Gregory Elem.

Manley H.S.

800 S

Sears, Roebuck & Co. – Headquarters

HAPOEL HAMIZRACHI- RELIGIOUS ZIONISTS

GRENSHAW ST. TALMUD TORAH

RITUAL BATHS

1200 S

Roosevelt

RITUAL BATHS

TEMPLE JUDEA

HEBREW PAROCHIAL SCHOOL

KNESSES ISRAEL

ANSHE MAKAROV CONG.

NUSACH SFARD CONG. (K.I.N.S.)

ANSHE ROUMANIA

14th

UNITED PAVALITCHER C.

JEWISH PEOPLE'S INSTITUTE

HEBREW THEO- LOGICAL COLLEGE

HOME OF JEWISH BLIND

Lawson Elem.

ABC

JEWISH DAILY FORWORD

POALE ZION

LABOR ZIONIST

Douglas Blvd

DOUGLAS

KEHILATH JACOB CONG.

HERZL JR. COLLEGE

K.J. TALMUD TORAH

BBR

MARCY CENTER

16th

ADAS B'NAI ISRAEL CONG.

BETH MEDROSH GODOL CONG.

ANSHE KNESSES ISRAEL CONG. (RUSSICHE)

MOSES MONTEFIORE TALMUD TORAH

MISHNE U'GEMORAH CONG.

MARKS NATHAN ORPHAN

JEWISH HOME

JEWISH DAY & NIGHT NURSERY

REST HAVEN HOME

JEWISH PEOPLE'S CONVALESCENT HOME

MT. SINAI HOSPITAL

Ogden

Penn Elem.

Howland Elem.

WORKMAN'S CIRCLE–YIDDISH THEATRE

ORTHODOX JEWISH HOME FOR THE AGED

PARK

Pope Elem.

1900 S

19th

This map of 1948 displays major Jewish and other institutions in the heart of Lawndale. (Map by Irving Cutler.)

The "Russische Shul," Anshe Kanesses Israel Congregation, was located on Douglas Boulevard near Homan Avenue from 1916 to 1952. Like most of the synagogues in Lawndale, it moved from the Maxwell Street area where it was founded in 1875. It had a seating capacity of about 3,500 and contained 35 Torah scrolls. Some of the best cantors from the eastern United States and from Europe would conduct the high holiday services. Rabbi Ephraim Epstein was the congregation's rabbi for almost half a century. (From Meites.)

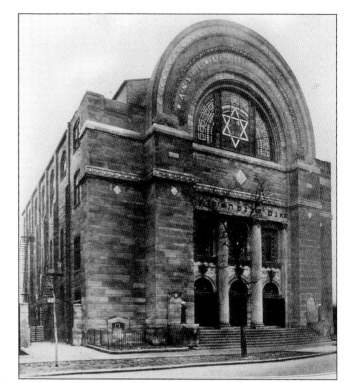

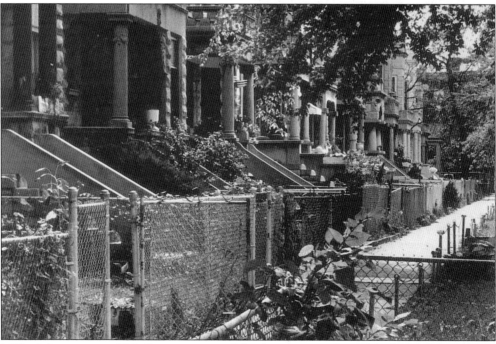

Millard Avenue near 18th Street was one of the few streets in Lawndale that contained some single-family homes. Most buildings were two-flat, three-flat, or larger apartment buildings. One of a number of reasons for the exodus from Lawndale after World War II was the desire of families to have homes of their own. (Photo by Dr. Julius Wineberg.)

Three important institutions were located at the intersection of 13th Place and Homan Avenue. On the left was the Lawson Elementary School, which was almost all Jewish. On the right, was the American Boys' Commonwealth (ABC), a Jewish boys' club featuring athletics and crafts. In the background, was the Douglas Public Library which had a large Yiddish and Hebrew collection and where, for a short while, worked a young librarian by the name of Golda Meir. (Photo by Irving Cutler.)

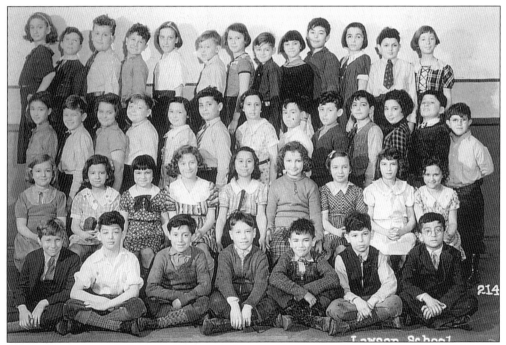

The students pictured above *c*. 1933 are at Lawson Elementary School, located at 1256 South Homan Avenue. (Courtesy of Debra M. Greenberg.)

William Penn Elementary School was located at 1616 South Avers Avenue. Most of its students, virtually all Jewish, went on to either Marshall or Manley High School. (Courtesy of Debra H. Greenberg.)

Homemade scooters constructed by Lawndale kids from apple or orange crates, a split skate, and pop cans for ornamentation were inexpensive Depression-era transportation. (Courtesy of Special Collections, University of Illinois at Chicago Library.)

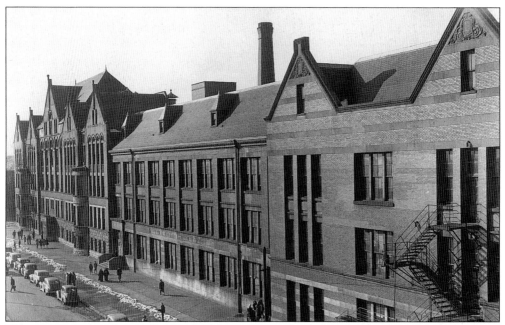

The majority of students who lived in Lawndale went to Marshall High School located at Kedzie and Adams Streets. The school was highly rated academically and athletically—its basketball team once won 99 consecutive games. For a number of years it offered a course in the Hebrew language, the only Chicago public high school to do so. (Courtesy of Sid Bass.)

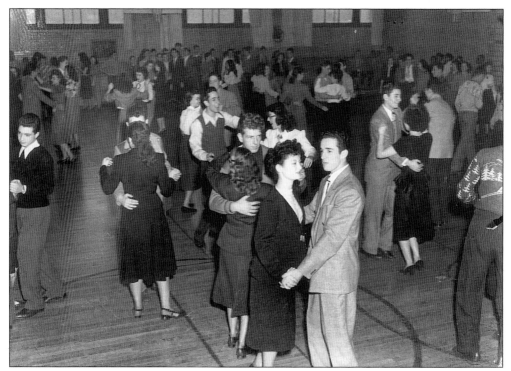

Students dancing at a social at Marshall High School, c. 1947. (Courtesy of Sid Bass.)

40

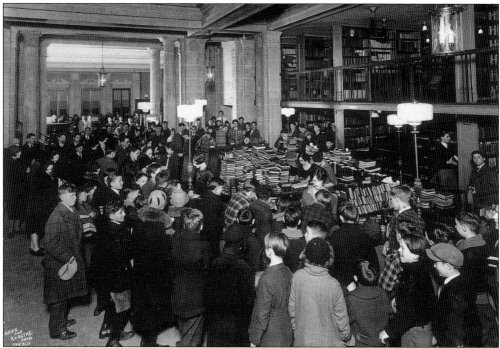

Book readers, like those pictured above in 1926, would spend a good deal of time at the Legler Branch of the Chicago Public Library at 115 South Crawford (Pulaski) Avenue. (Courtesy of the Chicago Public Library Archives.)

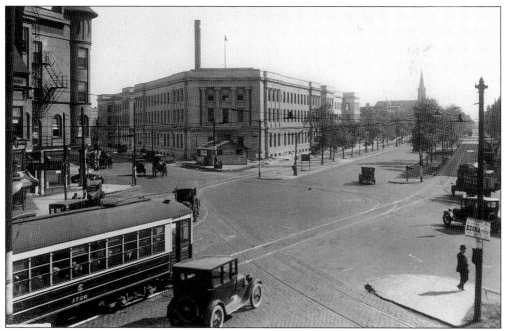

Youngsters who misbehaved were often threatened by their parents that they would be sent to the Audy juvenile detention center at Roosevelt Road and Ogden Avenue on the eastern edge of the Lawndale area. Few were ever actually sent. (Courtesy of the Chicago Historical Society.)

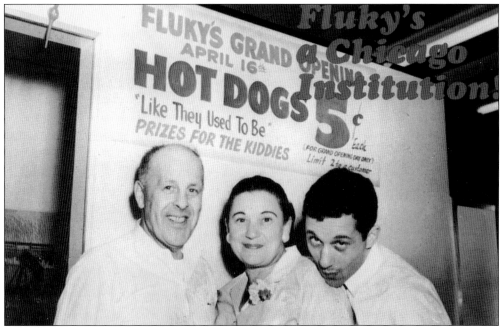

A favorite place for hot dogs was Fluky's on Roosevelt Road near Central Park Avenue. It was the same block that contained Ye Olde Chocolate Shop, The Central Park and Twentieth Century Theaters, Best Kosher Sausage, and Silverstein's Delicatessen.

Mt. Sinai Hospital at California Avenue and 15th Street, opposite Douglas Park, opened in 1912 through the efforts of Eastern European Jews who wanted a hospital that would follow kosher dietary practices and serve the burgeoning Jewish population occupying much of the surrounding West Side area. Partially funded by the Jewish Federation of Metropolitan Chicago, it still serves newly arrived Russian as well as poor Jews. Across the street is the Schwab Rehabilitation Center. (Mt. Sinai Hospital.)

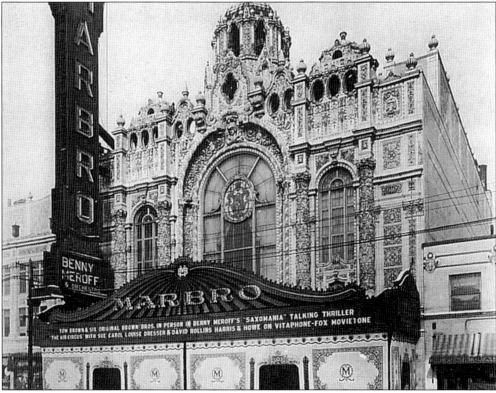

The Balaban and Katz Marbro Theater was on Madison Street near Crawford Avenue, 1927. The canvas awning provided protection against Chicago's cold winters. The theater, featuring vaudeville plus movies, was part of a busy retail entertainment complex that included a number of theaters, the Guyon Paradise Ballroom, and the Midwest Athletic Club.

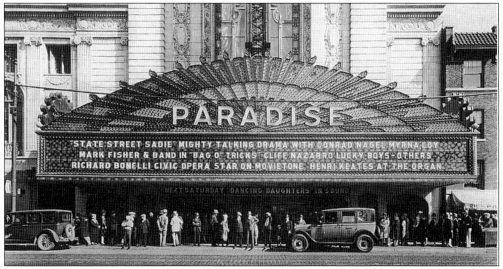

The Paradise Theater, pictured here in 1928, was located on Crawford Avenue just north of Madison Street. It was noted for its lavish interior decor, which included stars in the ceiling and, for a while, it had a nursery where one could leave children.

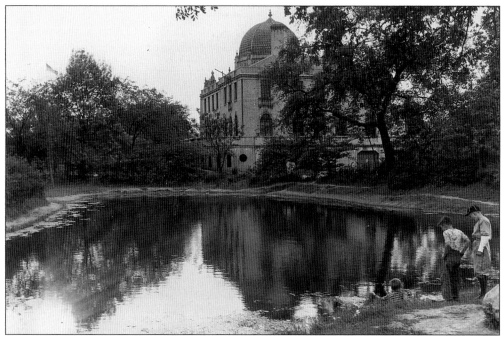

Garfield Park, like Douglas Park at the other end of the community, had a wide variety of athletic, boating, and floral facilities as well as free weekend band concerts in the summer. On hot summer nights, before air conditioning, people would take their pillows and sleep safely in the park. The gold dome recreation center is shown in the background.

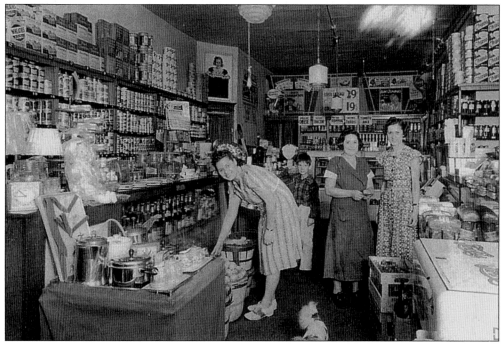

Isadore and Lillian Greenberg's "mom and pop" grocery store was located at Hamlin and Fulton Streets in the Garfield Park area, 1940. (Courtesy of Debra M. Greenberg.)

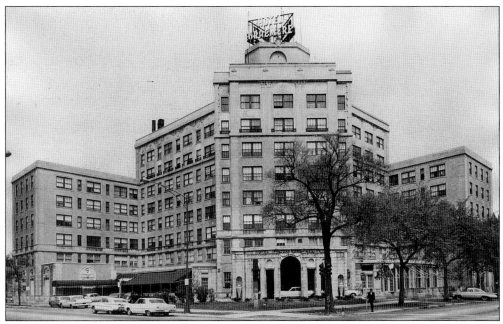

The Graemere Hotel, opposite Garfield Park at Homan Avenue and Washington Boulevard, was used extensively by Jews of the Lawndale, Garfield Park, and Austin area for weddings, Bar Mitzvahs, and a variety of meetings and social events. (Courtesy of the Chicago Historical Society.)

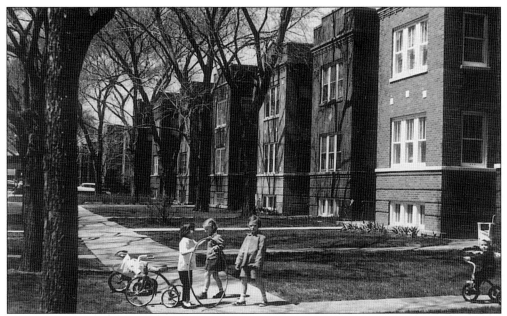

A block of two family homes in 1940 in the community of Austin which had an estimated 7,000 Jews living among other ethnic groups. Jews lived there from around 1915 into the late 1960's and were perceived to be more prosperous and, perhaps, somewhat more assimilated than those living to the east in Lawndale. There were several synagogues in Austin. (Courtesy of Harold M. Mayer.)

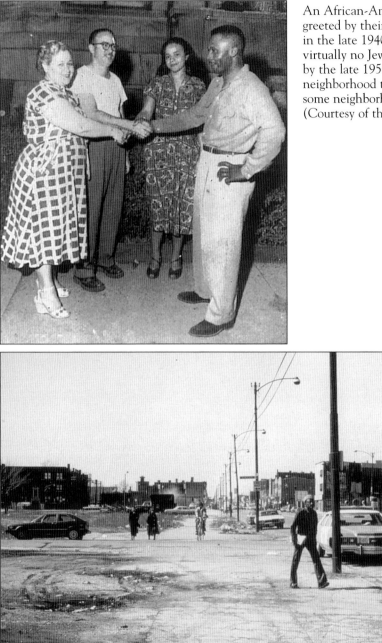

An African-American couple being greeted by their Jewish neighbors in the late 1940s. There were virtually no Jews left in Lawndale by the late 1950s, although the neighborhood transition, unlike in some neighborhoods, was peaceful. (Courtesy of the *Sentinel*.)

Looking west along Roosevelt Road from Kedzie Avenue in 1970 following the 1968 riots and burnings that followed the assassination of Dr. Martin Luther King. There were once two banks at the intersection. To the left were the popular Carl's Delicatessen, the Circle Theater, B. Nathan's Dress Shop followed for more than a mile by other well known Jewish stores, theaters, and meeting halls. Across the street were the also well known "Zookie the Bookie" and Davey Miller's Pool Hall. For many, a memorable and unforgettable era had come to an end. (Photo by Irving Cutler.)

Four

NORTH AND
NORTHWEST SIDES

After the Chicago Fire, a small number of Jews moved north of the river and, for a number of years, there existed a Jewish community about 2 miles north of downtown in an area known today as Old Town. The area at that time supported three synagogues. The extension of the elevated lines around the turn of the century to Humboldt Park, Logan Square, Albany Park, and Rogers Park opened those areas to settlement. Of those settlers, many were Jewish, largely of Eastern European descent. Many were moving upward economically and socially from their place of first settlement in the Maxwell Street area.

These areas differed from the crowded Maxwell Street area in that they were physically attractive communities, not solidly Jewish, nor mainly Orthodox. There were Reform, Conservative, Orthodox, secular, and some radical Jews in these areas. Each community had their Jewish retail streets such as Division Street, Milwaukee Avenue, Lawrence Avenue, and Morse Avenue as well as their own institutions. Though smaller in population than Lawndale, economically and even socially, they generally were considered by many a step above the large West Side community.

The Jews started the dispersal out of these neighborhoods in the decades after World War II. Many moved to West Rogers Park, today's largest Chicago Jewish community, but increasingly many moved into the suburbs, especially those to the north and northwest.

Founded in 1938, this Traditional synagogue was a place of worship for the young and old. Pictured here in 1995 is Congregation Beth Sholom of Rogers Park, 1233 West Pratt. (Photo by Joe Kus for *The Chicago Jewish News*.)

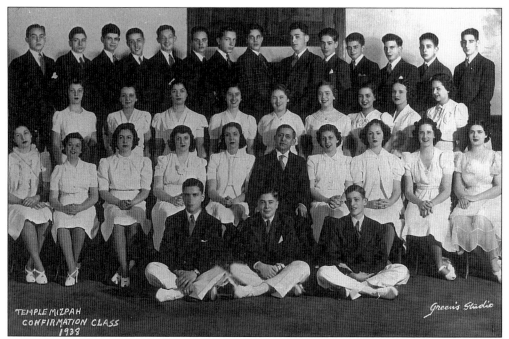

Pictured above is the 1938 confirmation class of Reform Temple Mizpah at 1615 West Morse Avenue. The temple was located there from 1929 through 1977. (Courtesy of Rogers Park/West Ridge Historical Society.)

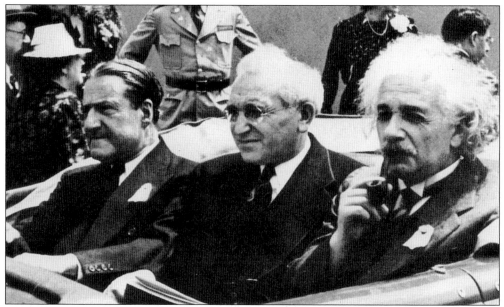

Riding in the center is Rabbi Solomon Goldman (1893–1953). This renowned rabbi of the Conservative Anshe Emet Synagogue for almost 25 years also served as president of the Zionist Organization of America. To his left is Rabbi Stephen Wise of New York, another prominent Jewish leader, and Professor Albert Einstein is on the right. (Courtesy of the Jewish Federation of Metropolitan Chicago.)

Senn High School, located at 5900 North Glenwood, had over a thousand Jewish students in 1950. Senn and Sullivan were the two major high schools attended by Jewish students of Lakeview, Uptown, and Rogers Park. (Courtesy of Harold M. Mayer.)

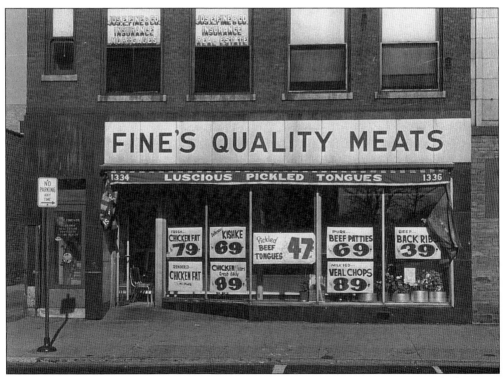

Fine's butcher shop, 1965, was located at 1334 West Morse Avenue in a Rogers Park that once held a large Jewish population. The Rogers Park, Uptown, and Lakeview communities contained about 27,000 Jews in 1940. (Courtesy of Rogers Park/West Ridge Historical Society.)

The Edgewater Beach Hotel at 5349 North Sheridan Road along the lake, with its famous boardwalk, was a popular place for Jewish social events and meetings when this picture was taken in 1929. It lost much of its attractiveness when it became landlocked with the extension of Lake Shore Drive north of Foster Avenue. It was later replaced by residential facilities. (Courtesy of the Chicago Historical Society.)

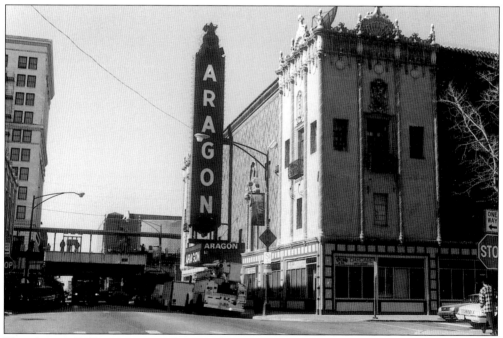

The Aragon Ballroom at Broadway and Lawrence Avenues was part of an entertainment complex that attracted many Jewish people. Around the same intersection were the Uptown and Riviera Theaters and the Green Mill Lounge. (Photo by Dan Cutler.)

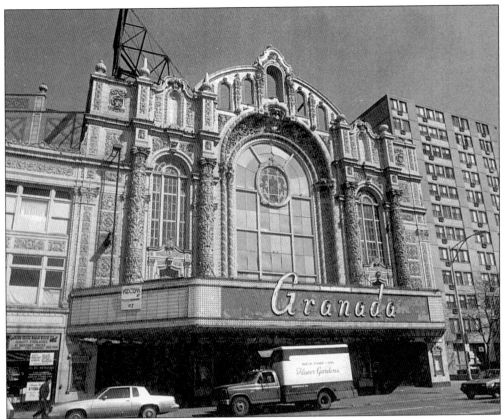

This once popular Balaban and Katz Granada Theater, pictured in 1987, was located on Sheridan Road north of Devon Avenue in the Rogers Park area. It has recently been replaced by a retail-residential complex.

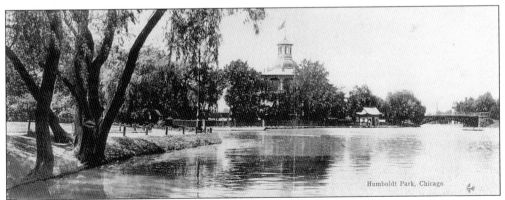

Humboldt Park was a focal point of the Humboldt Park, Logan Square, and West Town communities which, in the 1930s, numbered about 30,000 Jews and some 20 synagogues. Jewish radicals, fairly numerous in the area, often articulated their views from soap boxes around the perimeter of the park. Unlike Maxwell Street and Lawndale, which were almost solidly Jewish, the Jews never comprised more than perhaps one-quarter of the area's total population. (Courtesy of the Chicago Public Library.)

Koppel's Deli (Brown and Koppel) was a well known Jewish-style restaurant at the corner of Division Street and Damen Avenue in the area where many Jews first lived before moving further west toward Humboldt Park. The restaurant had a little discreet gambling in the back.

Moishe Pippic's popular delicatessen was located near Humboldt Park, c. 1960. (Courtesy of the Conrad Sulzer Regional Library.)

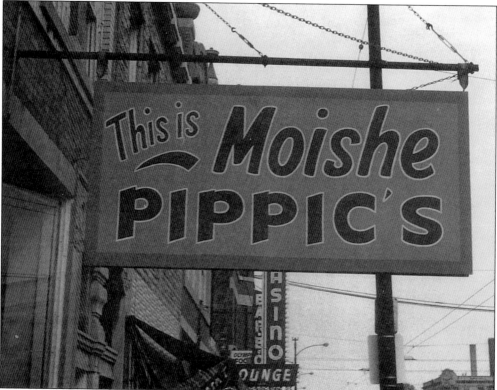

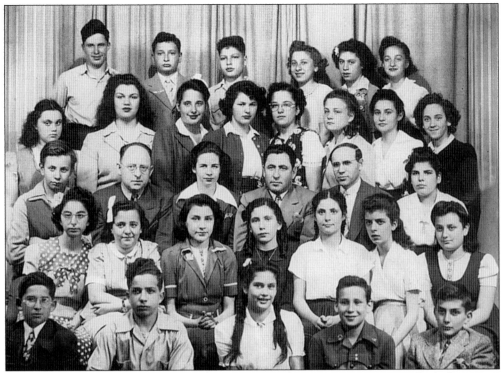

The photo shows combined groups of the International Workers Order Kindershul in 1944. The IWO was a leftist offshoot of the workingmen's socialistic Yiddish-oriented Workmen's Circle. (Arbeiter Ring.)

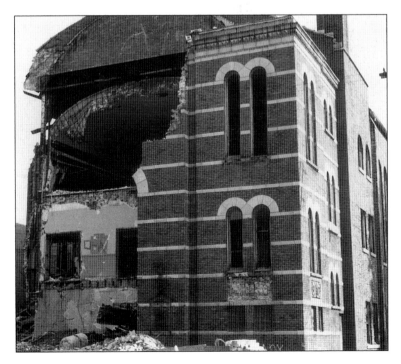

The demolition in 1977 of the Logan Square Conservative Congregation Shaare Zedek, located at Fullerton Avenue near Kedzie Avenue, marked the demise of the Logan Square Jewish community. Built in 1922, it had a seating capacity of 1,400. Its rabbis included Rabbi Birnbaum (cousin of actor George Burns) and Rabbi Lawrence Charney. (Photo by Irving Cutler.)

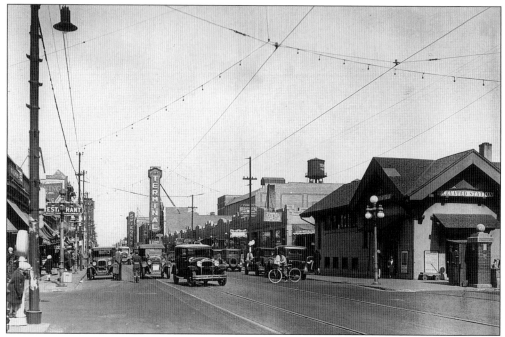

Lawrence Avenue, 1929, looking east from Kimball Avenue. This main commercial street of Albany Park, had a growing Jewish population then of almost 25,000 in 1929. To the right is the terminal of the Ravenswood elevated line, which opened in 1907 and started movement into the community. Also on the right is the popular Purity Restaurant. (Courtesy of the Chicago Historical Society.)

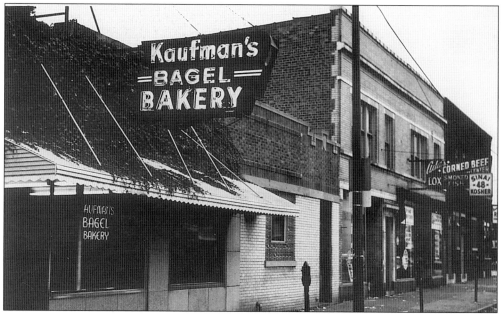

Kaufman's Bagel Bakery and Ada's Delicatessen were both on Kedzie Avenue just north of Montrose Avenue in Albany Park, 1981. They are now both located in the northern suburbs. (Photo by Irving Cutler.)

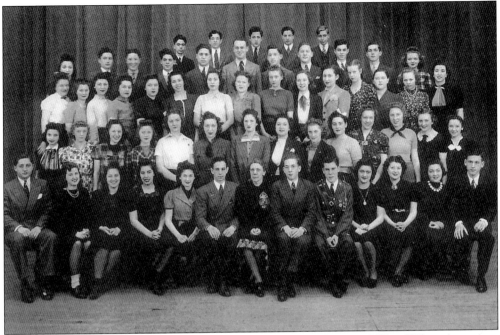

Class picture at Roosevelt High School, located in Albany Park at 3436 West Wilson Avenue, *c.* 1935, a time when it had a large Jewish population. (Courtesy of Conrad Sulzer regional Library.)

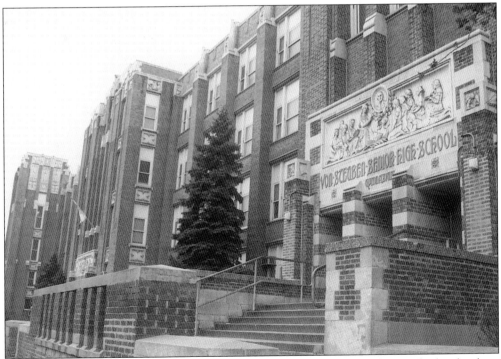

Von Steuben High School, 5039 North Kimball Avenue, was one of the two high schools in the Albany Park/North Park area that the Jewish students attended. The other was Roosevelt High School. (Photo by Irving Cutler.)

The first Albany Park synagogue was Reform Temple Beth Israel, founded by German Jews in 1917. Until 1981, it was at 4850 North Bernard Avenue. Today, it is located in Skokie. Like many synagogues in Albany Park, the building is now a Korean church. Its long time spiritual leaders were Rabbis Felix Mendelsohn and Ernst M. Lorge. Its members included Shimon Agranat, later Chief Justice of Israel, and Seymour Simon, later a justice of the Illinois Supreme Court. (Photo by Irving Cutler.)

Kindergartners graduating in 1946 at the Max Straus Jewish Community Center at 3707 West Wilson Avenue. The center opened in 1941 and closed in 1968, after most of the Jewish population had moved out of the Albany Park area. (Courtesy of Conrad Sulzer Public Library.)

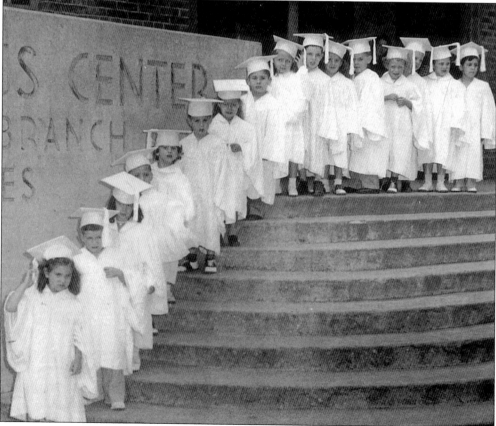

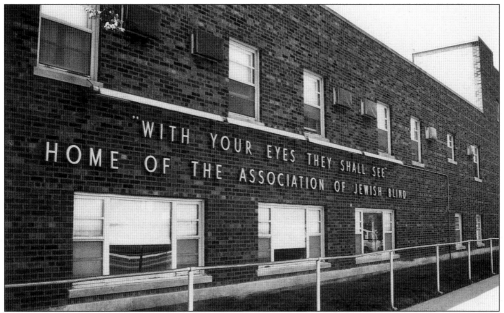

The Home of the Association of Jewish Blind (now Kagan Home for the Blind), 3525 West Foster Avenue, was founded in 1932 by self-sufficient Jewish blind men and women. It was located on Douglas Boulevard in Lawndale until 1943. It is a kosher facility that contain a synagogue. (Photo by Irving Cutler.)

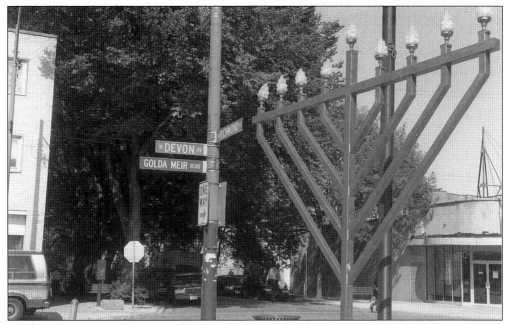

A Chanukah menorah on Devon Avenue, next to the Friends of Refugees of Eastern Europe (F.R.E.E.) building, is located at 2935 West Devon Avenue. In this picture taken in 1998, note the honorary Golda Meir street sign. East of California Avenue on Devon Avenue are Mahatma Gandhi, Mother Theresa, and Ali Jinnah honorary street signs reflecting the Indian and Pakistani character of the former Jewish commercial strip. (Photo by Irving Cutler.)

Pictured is the countdown to the Sabbath in front of glatt-kosher Kosher Karry, 2828 West Devon in West Rogers Park, 1997. (Courtesy of *The Chicago Jewish News*.)

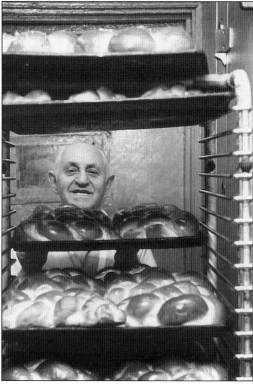

Baker at Gitel's Bakery located at 2745 West Devon Avenue stacks Sabbath challah bread. (Courtesy of *The Chicago Jewish News*.)

Merchandise is proudly displayed at the Good Morgan Kosher Fish Store at 2948 West Devon Avenue. (Courtesy of *The Chicago Jewish News*.)

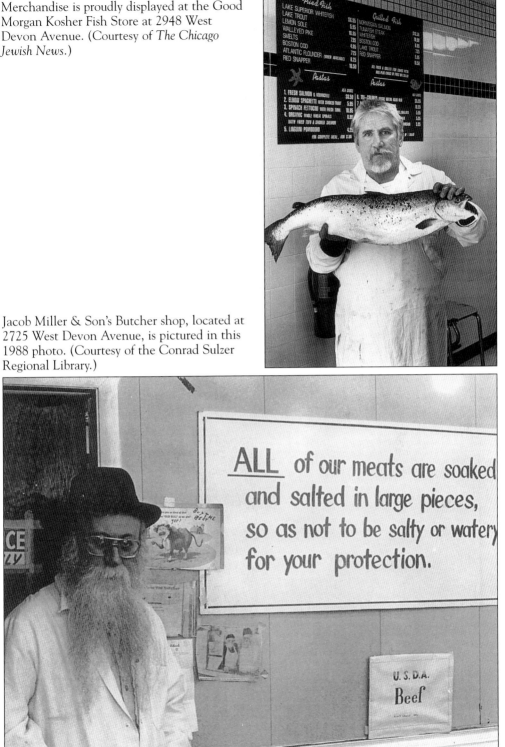

Jacob Miller & Son's Butcher shop, located at 2725 West Devon Avenue, is pictured in this 1988 photo. (Courtesy of the Conrad Sulzer Regional Library.)

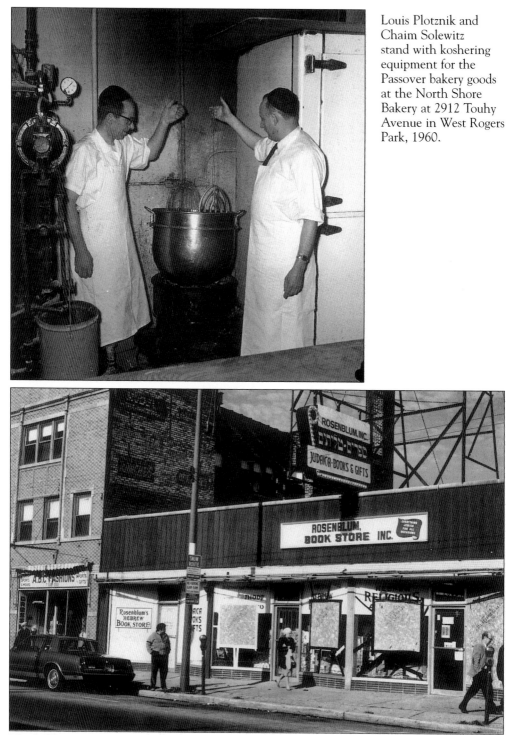

Louis Plotznik and Chaim Solewitz stand with koshering equipment for the Passover bakery goods at the North Shore Bakery at 2912 Touhy Avenue in West Rogers Park, 1960.

The broken windows at the Rosenblum's Book Store, 2906 West Devon Avenue, were the result of a night of vandalism that occurred on November 9, 1977—the anniversary of *Kristallnacht*. (Photo by Irving Cutler.)

Two unusual, adjacent kosher Jewish restaurants located at 3010–3014 West Devon Avenue in West Rogers Park in 1999. (Photo by Irving Cutler.)

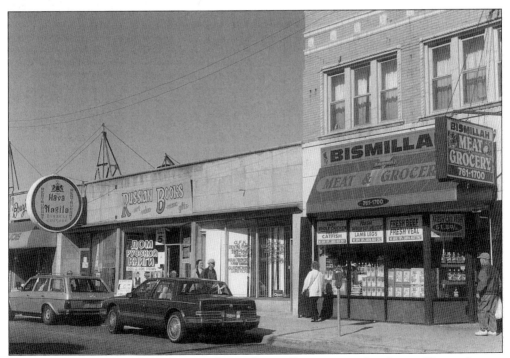

Jewish, Russian, and Arab facilities are located virtually next to each other on Devon Avenue just east of California Avenue in 1998. (Photo by Irving Cutler.)

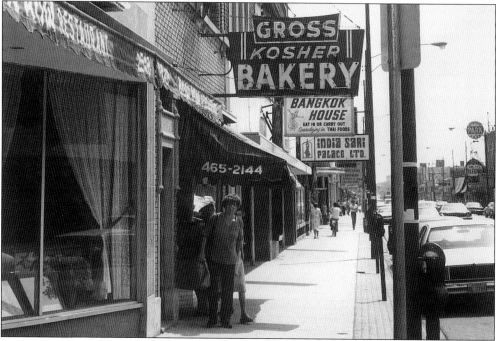

The changing neighborhood is reflected by the stores along Devon Avenue east of California Avenue, c. 1990.

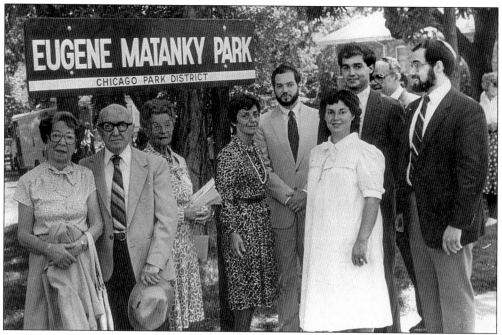

Family members dedicate the Eugene Matanky Park of the Chicago Park District at Morse and Ridge Avenues in 1984. The late Eugene Matanky was a well known real estate developer who was also very active in Jewish communal affairss as are other family members. (Courtesy of the Rogers Park/West Ridge Historical Society.)

Five

PEOPLE

This chapter's photos depict a variety of Jewish people, from the German Jews to the Eastern European Jews, from the young to the old, from the rich to the poor, from family groups to political groups, as well as groups demonstrating against injustice, groups aiding Soviet Jews and Israel, or participating in wartime activities. It is a spectrum of the diversity of the Jewish community.

Taken in 1900, this photo shows prominent German-Jewish club women at a social-political event in Chicago. (Courtesy of the Special Collections, University of Illinois at Chicago Library.)

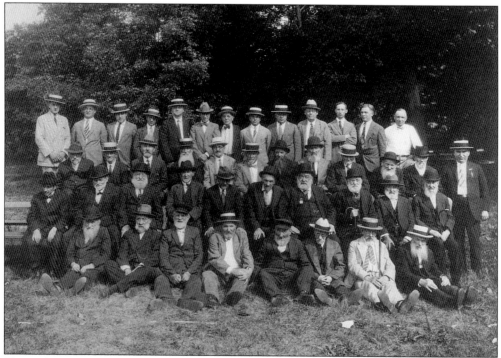

Shown here are male residents of the Orthodox Home for the Jewish Aged, the Beth Moshav Z'Keinam (BMZ), at 1648 South Albany opposite Douglas Park in the 1920s. (Courtesy of the Jewish Federation of Metropolitan Chicago.)

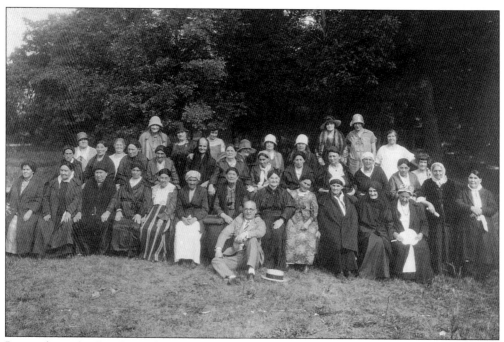

Pictured are the female residents of the Orthodox Home for the Jewish Aged in the 1920s. (Courtesy of the Jewish Federation of Metropolitan Chicago.)

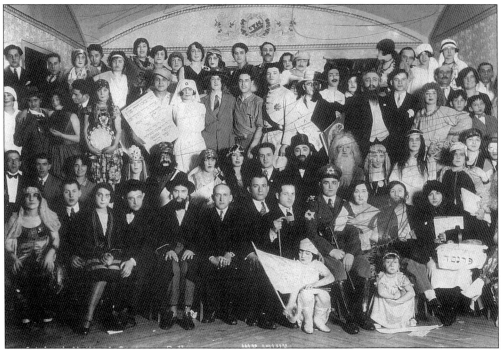

This photo depicts the February 5, 1927 Labor Zionist annual costume ball in Chicago. (Courtesy of the Chicago Jewish Archives.)

This 1970 picture, taken on July 26, shows the Reader-Maslawsky-Greenberg Cousins Club annual picnic in Galitz Park, Skokie. (Courtesy of Debra M. Greenberg.)

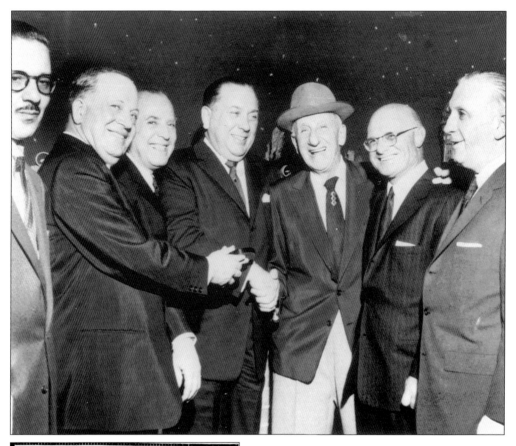

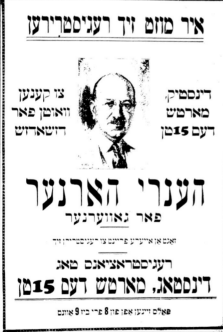

אּיר מוזם זיך רעגיסטרירען

העגרי האָרנער
פּאַר גאָװערנער

דינסטיק,
מּאַרטש
דעם 15טן

צו קענען
וואוטן פּאַר
דושאָרש

וואָס און אּייערע פּריינט צו רעגיסטרירן זיך

רעגיסטראַציאָנס טאָג.
דינסטאָג, מּאַרטש דעם 15טן

פּאָלס זיענען אָפּן פּון 8 פּרי ביז 9 אּוונט

On the Sunday before every major election, the powerful 24th Ward Democratic Organization would hold a "get out the vote" political rally at the Herzl school on Douglas Boulevard, often bringing a celebrity. Shown here from left to right are Arthur Schimmel, Arthur Elrod, Abraham Lincoln Marovitz, Major Richard J. Daley, Jimmy Durante, Jacob Arvey, and Sidney Deutch. All except Durante were well known Democratic political figures. (Courtesy of Arthur Schimmel.)

A campaign poster in Yiddish for Henry Horner for governor in 1932. He served as the first Jewish governor of Illinois from 1933 to 1940. His grandfather, of the same name, was one of the first Jewish immigrants to Chicago in 1841 and was an organizer of the Chicago Board of Trade.

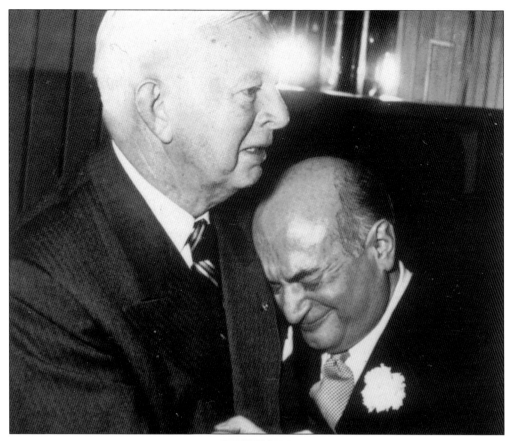

Mayor Martin Kennelly (left) and City Treasurer Maurice B. Sachs console each other after their defeat for reelection in the February 22, 1955 Democratic primary. Sachs owned a highly successful clothing store in Englewood and sponsored a popular radio amateur hour. (Courtesy of the Chicago Jewish Archives.)

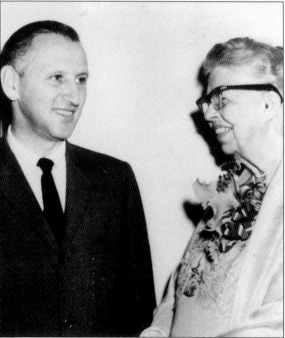

Congressman Sidney Yates represented the North Side of Chicago in the U.S. House of Representatives from 1949 to 1999, with the exception of one term. Pictured here with Eleanor Roosevelt, this son of immigrant parents was a champion of the arts and environmental protection, as well as one of the promoters of the Holocaust Museum in Washington. (Courtesy of the Chicago Jewish Archives.)

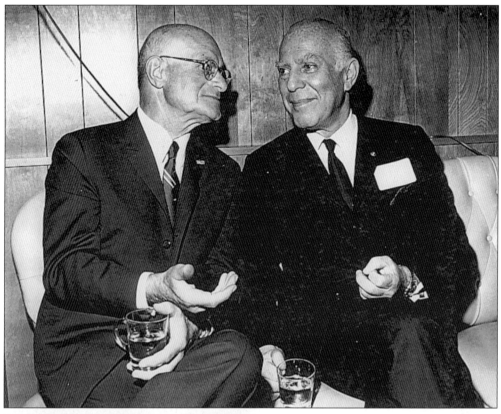

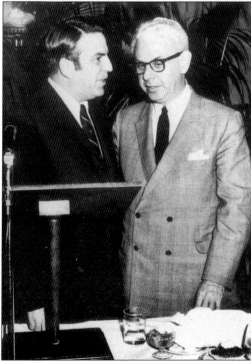

Jacob Arvey (left) and Abraham Lincoln Marovitz, c. 1962, were two popular Democratic political figures who had lived in Maxwell Street and Lawndale. Arvey served as alderman of the powerful Democratic 24th Ward from 1923 to 1941, and later held a number of influential positions in the local, state, and national Democratic Party. Marovitz held a number of important local and state offices before becoming a federal district judge. Both were very active in Jewish organizations. (Courtesy of the Chicago Jewish Archives.)

Abner J. Mikva (left) and Arthur Goldberg were law partners at one time. Mikva served in both the Illinois and U.S. House of Representatives, as a U.S. Court of Appeals judge in Washington, and as an advisor to President Clinton. Goldberg served as U.S. Secretary of Labor, United Nations Ambassador, and U.S. Supreme Court Justice. (Courtesy of the Chicago Jewish Archives.)

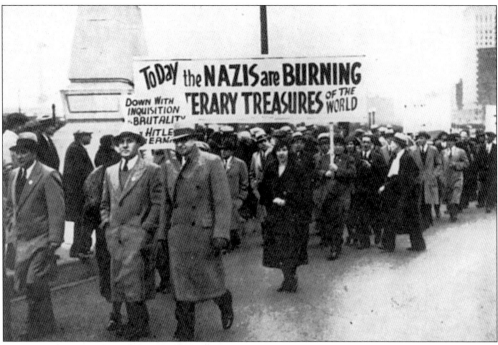

An anti-Nazi demonstration on May 10, 1933, in Chicago on the day the Nazis were burning books by Jews, liberals, and social revolutionaries.

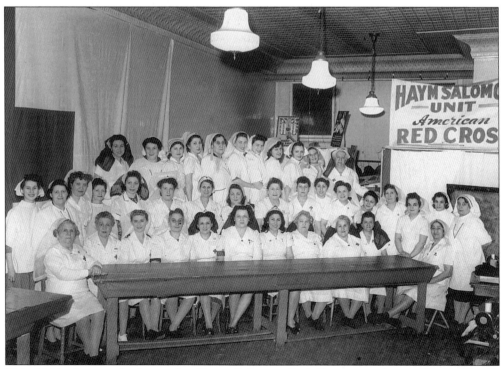

This 1944 photograph shows the Haym Solomon Red Cross unit during World War II. (Courtesy of the Chicago Historical Society.)

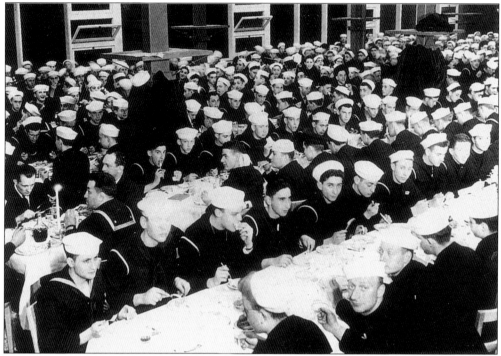

This 1943 wartime Passover Seder at the Great Lakes Naval Training Station at North Chicago was organized by Mrs. Jacob (Clarissa) Schwartz of Waukegan and Chaplain Julius Mark. (Courtesy of the Jewish Federation of Metropolitan Chicago.)

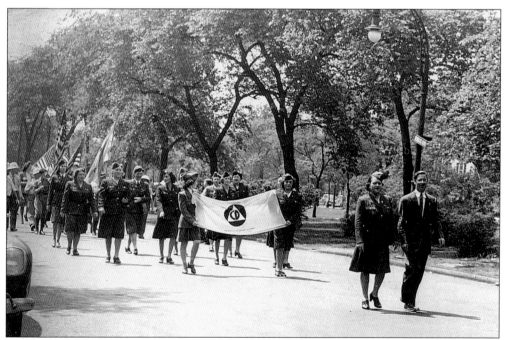

Jennie Greene (Greenberg) and Arthur Schimmel lead a Civil Defense parade down Douglas Boulevard in Lawndale on June 13, 1944. (Courtesy of Debra M. Greenberg.)

Most of the members of this Rogers Park Chapter of B'nai B'rith, 1946, were World War II veterans. (Courtesy of the Chicago Historical Society.)

BE THANKFUL!
for the fulfillment of a 2000 years' dream

SALUTE JEWISH STATE IN PALESTINE!

Show your appreciation--

Observe this Holiday by closing all **Stores, Factories, Shops** and **Offices,** all day **Saturday, May 15**

Gather in masses, SABBATH, MAY 15th, at your holy places of worship and offer a prayer of thanks for the Jewish State.

DO NOT FAIL TO PARTICIPATE IN THE RALLY AT THE CHICAGO STADIUM

Sunday, May 16th, 8 P. M.

Merkaz Harabanim of Chicago
Chicago Rabbinical Council
Rabbinical Council of Chicago
Rabbinical Assembly of America
Rabbinical Association of Chicago
Union of Orthodox Jewish Congregations of America
United Synagogues of America
Chicago Bnai Brith Council
Council of Conservative Synagogues
Hashamen Hadati of Chicago
Hapoel Hamizrachi of America
Mizrachi Organization of America
Young Israel of America

Associated Talmud Torahs of Chicago
Rabbi Eliezer Silber, Chief Rabbi of Cincinnati, Ohio
Hebrew Parochial School of Chicago
* Board of Jewish Education
* Jewish War Veterans of America
Synagogue Division, Jewish Welfare Fund
Vaad Hatzalah of America
Vaad L'Maan Hashabbos
American Jewish Congress
Zionist Organization of America
* American Federation for Polish Jews

Massive rallies backed by virtually all Jewish groups were held immediately after the proclamation of the State of Israel on May 14, 1948. (Courtesy of Jerome Robinson.)

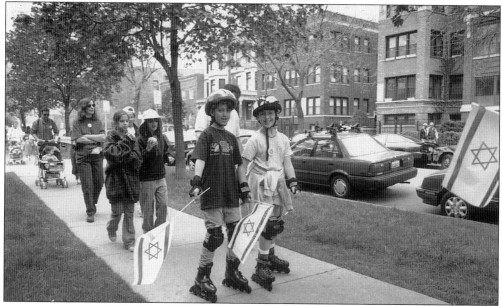

Thousands of people of all ages showed their support for Israel by walking, running, biking, dancing, and even roller-blading at the Annual Walk For Israel held throughout the Chicago area. (Courtesy of *The Chicago Jewish News*.)

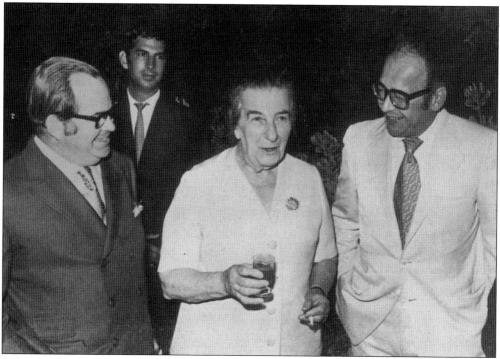

Robert Adler (left) and Raymond Epstein (right), pictured here with Golda Meir, were both past presidents of the Jewish Federation of Metropolitan Chicago. The Israeli Prime Minister had lived in Chicago for a short period and worked as a librarian at the Douglas Public Library in Lawndale. (Courtesy of the Jewish Federation of Metropolitan Chicago.)

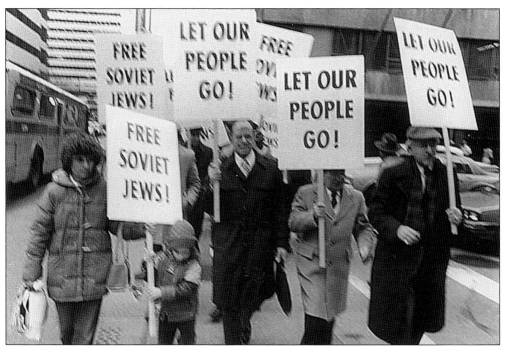

Protesters rally against Soviet policy toward Jews in the 1970s. A change in Soviet policy later allowed over 20,000 Soviet Jews to settle in Chicago. (Courtesy of the Jewish Federation of Metropolitan Chicago.)

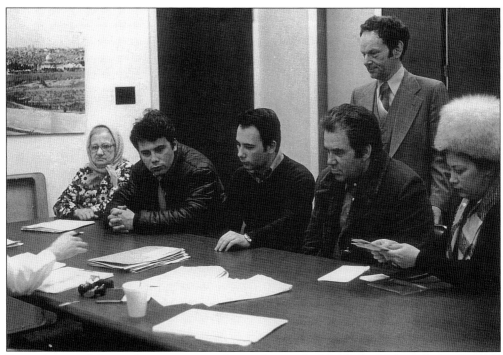

Recently arrived Soviet Jews were assisted in settlement by HIAS, the Hebrew Immigrant Aid Society, *c.* 1980s. (Courtesy of the Chicago Jewish Archives.)

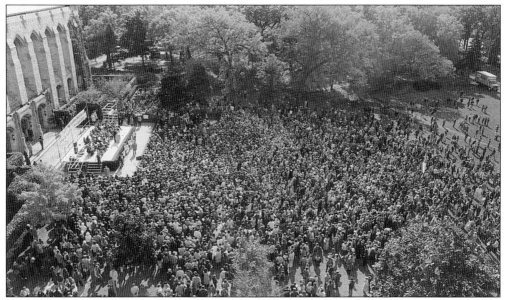
More than four thousand people gathered at Northwestern University on October 19, 1980, to participate in an anti-Nazi, community wide, interfaith demonstration of solidarity.

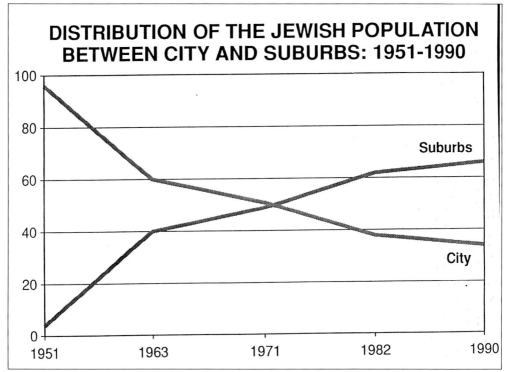

DISTRIBUTION OF THE JEWISH POPULATION BETWEEN CITY AND SUBURBS: 1951-1990

The post-World War II period witnessed a major shift of the Jewish population of the area from the city to the suburbs. In 1951, just four percent of the Jews lived in the suburbs; by 1990, 67 percent of the Jews were living in the suburbs. (Courtesy of the Jewish Federation of Metropolitan Chicago.)

Six

LABOR, COMMERCE, AND INDUSTRY

The early-arriving German Jews generally did well in business and the professions, but the later-arriving, poorer immigrants, mainly Eastern European Jews, were subjected to the exploitive "sweatshop" conditions of the period. In time, however, they began to protest these conditions and to organize what were to become progressive unions, such as the Amalgamated Clothing Workers of America and the International Ladies Garment Workers' Union. With the unions came labor leaders, some of whom became national figures like Sidney Hillman, Samuel Levin, Bessie Abramowitz, Jacob Potofsky, and Lillian Herstein. In commerce, many started as peddlers, then became small store owners, and some started companies that are still household names. Increasing numbers also did well in the professions, and Jews made important contributions in the arts, medicine, law, and other fields.

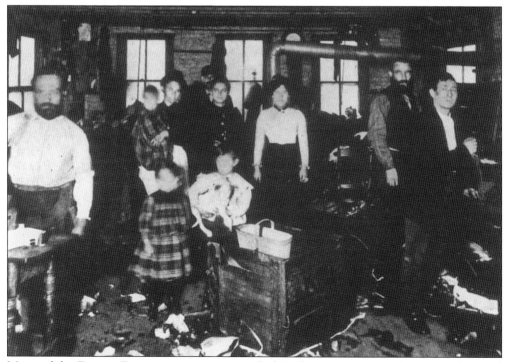

Many of the Eastern European immigrants worked in the garment sweatshops in and around downtown, 1902. They worked long hours for low pay in often crowded and unsanitary conditions with prevalent child labor. Some of the factories were owned by German Jews.

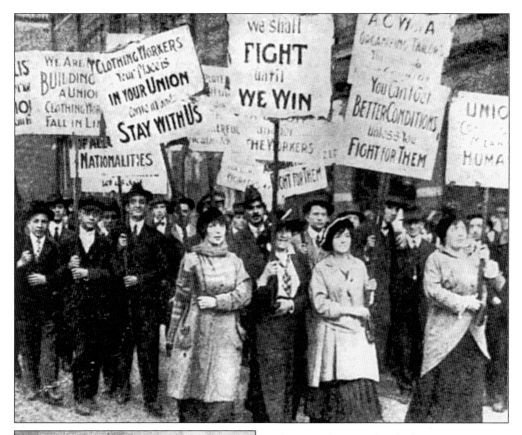

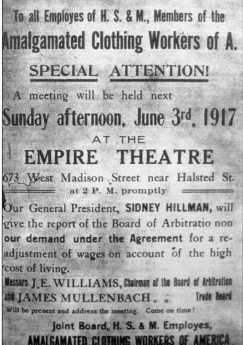

The Amalgamated Clothing Workers of America was officially established in 1914 after a bitter 17 week strike in the industry in 1910 when some 40,000 workers, 80 percent Jewish, walked off their jobs. Well before the E.R.A movement, women were among the strike and union leaders. (From the *Sentinel*.)

A poster for a meeting to be held by the Amalgamated Clothing Workers of America in 1917. Sidney Hillman (1887–1946), an immigrant from Lithuania, was a founder and president of the union for 30 years as well as holding high government positions in Franklin Roosevelt's administration. He played a key role in the passage of labor legislation.

A union poster in Yiddish and English publicized a mass meeting at the Workmen's Circle Labor Lyceum in 1926. There were several dozen Jewish unions, ranging from the Shochtem Union (ritual slaughterers) to the Carpenters' Union. Some Jewish unions were organized when hostility was experienced in the general unions because of religious and cultural differences, or because some Jewish immigrants were willing to work for lower wages.

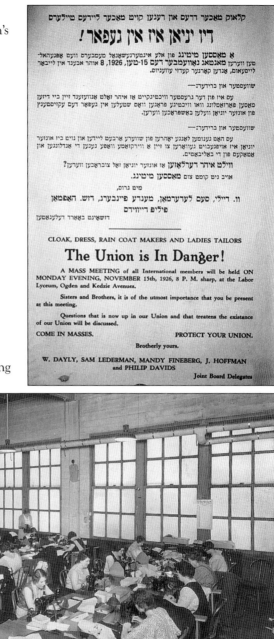

Taken c. 1930, this photo shows a Jewish owned clothing factory after better working conditions had been established.

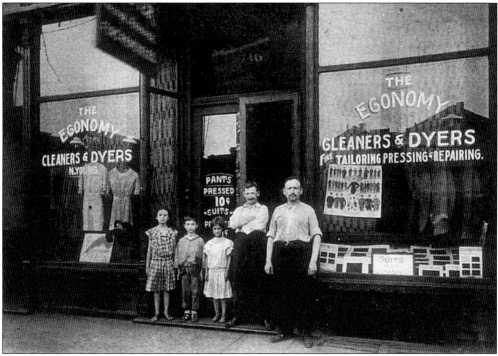

The photograph above shows a small business at 716 South Racine Avenue, *c.* 1910. (Courtesy of the Chicago Jewish Archives.)

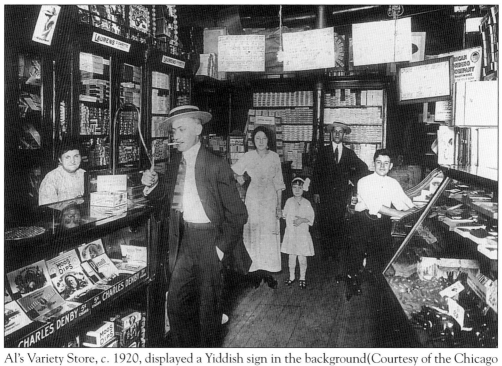

Al's Variety Store, *c.* 1920, displayed a Yiddish sign in the background (Courtesy of the Chicago Jewish Archives.)

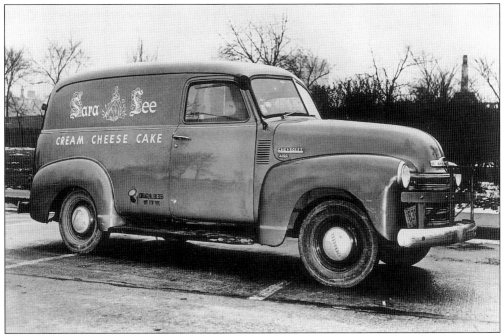

Sara Lee Cheese Cake was developed in Chicago by Charles Lubin. Lubin started out as an apprentice baker at the age of 14. The cake was named after his daughter. (Courtesy of the Sara Lee Corporation.)

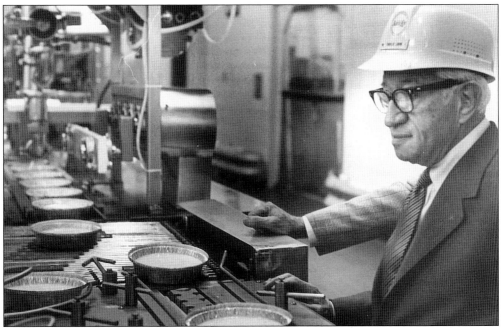

Charles Lubin is pictured here at the Sara Lee Bakery on Founder's Day, 1977. In 1956, his baking company was purchased by the food conglomerate Consolidated Foods, which was founded by Nathan Cummings. Consolidated Foods's name was later changed to the Sara Lee Corporation. (Courtesy of the Sara Lee Corporation.)

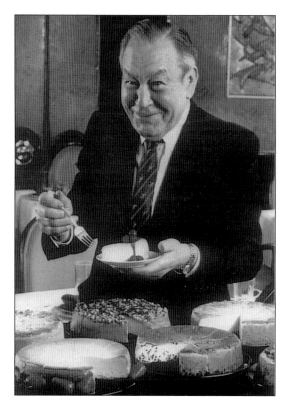

Eli Shulman, founder of Eli's Cheesecake Company, started with a small restaurant, "The Ogden Huddle," in Lawndale. Later, he opened "Eli's the Place for Steak" near downtown, where he developed his cheesecake dessert. From a new plant on the northwest side, the company now produces about fifty different cheesecakes that are sold all over the world. Huge cakes have been produced for major presidential and public events. (Courtesy of Marc Shulman.)

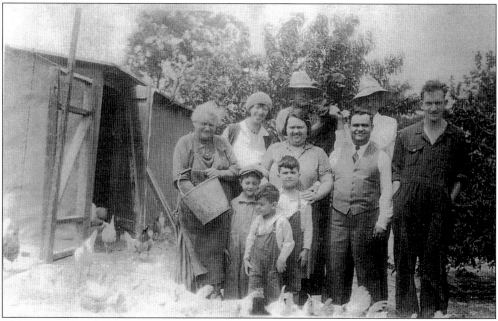

The Louis Jesilow family is pictured above on its farm in the Fox River Heights area in 1931. There have been a small number of Jewish farmers in the area starting with Henry Meyer, who farmed briefly in the 1840s in the area that is now Schaumburg. (Courtesy of Debra M. Greenberg.)

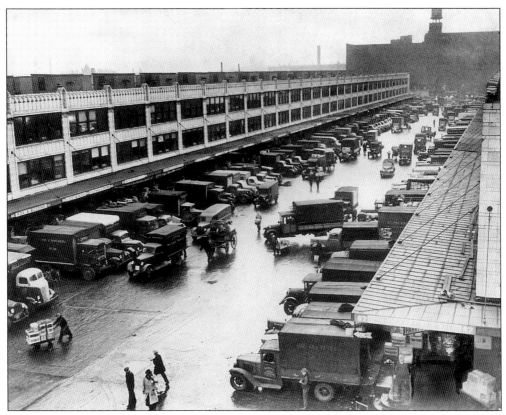

South Water Market, c. 1941, around 15th Street and Aberdeen Avenue, was opened in 1925. It is the city's largest wholesale market with sales of over $1 billion annually. In the past, Jewish peddlers would load their wagons and trucks early in the morning and proceed to the various ethnic neighborhoods to sell their produce. Today, an estimated one-third of the market's merchants are Jewish. (Courtesy of the Chicago Historical Society.)

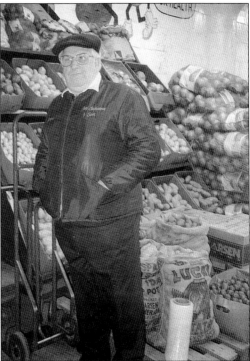

Ron Solomon, the owner of the South Water Market wholesale produce company, Irv Solomon and Sons, is pictured here in 1998. He is the third generation in the business that was founded by his Eastern European immigrant grandfather. (Photo by Margo Solomon.)

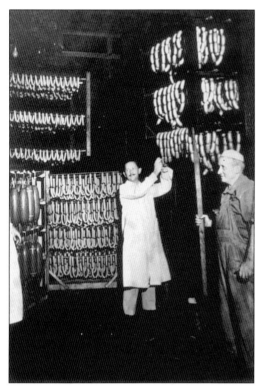

Producing sausage at the Vienna Sausage Company, 2501 North Damen Avenue. The original home of the company was in the Maxwell Street area at 1214 South Halsted Street. (Courtesy of the Vienna Sausage Company.)

While many Jews were in business and the professions, some were police officers, steel workers, garment laborers, and street car motormen. Pictured here is Louis Jesilow (right), a motorman on the Blue Island street car line, c. 1920s. (Courtesy of Debra M. Greenberg.)

Philip Klutznick (1907–1999), a prominent lawyer and major real estate developer, served in the federal government under seven presidents as director of the Federal Housing Authority, delegate to the United Nations, Secretary of Commerce, and other positions. Exceedingly active in Jewish affairs, he was international president of B'nai B'rith, general chairman of the United Jewish Appeal, and president of the World Jewish Congress. His local real estate developments include Park Forest and Water Tower Place. (Courtesy of the Jewish Federation of Metropolitan Chicago.)

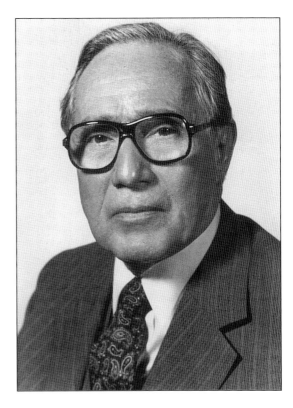

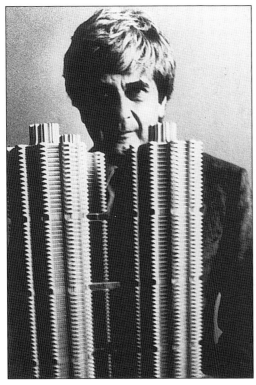

Bertrand Goldberg (1913–1997), a Chicago native and noted architect is shown here with a model of his most famous buildings, Marina Towers. The twin sixty-story circular buildings were erected downtown along the Chicago River in 1965. (Courtesy of the Bertrand Goldberg Associates, Inc.)

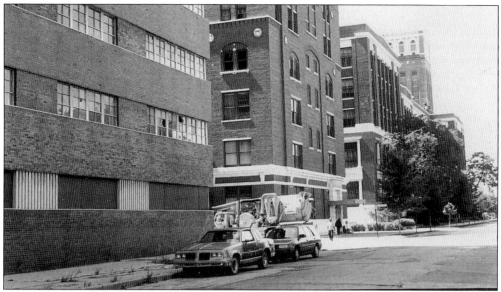

The enormous complex of Sears, Roebuck, and Company stretched for almost a half mile along Arthington Avenue in Lawndale. It included the Sears headquarters, its catalogue facilities, its Allstate Insurance subsidiary, and the first Sears store in the country. Thousands of workers including many Jews from nearby neighborhoods were employed there. For many years, Julius Rosenwald was chairman of the board of Sears. (Photo by Irving Cutler.)

Pictured above is a factory of the Florsheim Shoe Company located at Pulaski Road and Belmont Avenue. The company was founded by Sigmund Florsheim and other family members who had come from Germany in the mid–1800s. (Courtesy of the Florsheim Shoe Company.)

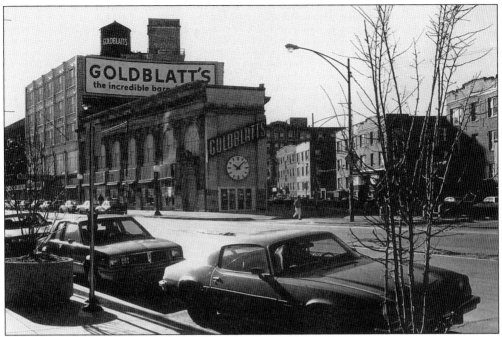

The Goldblatt's Brothers store at 4722 North Broadway in Uptown was one of a ten-store chain that was founded in 1914 by Nathan and Maurice Goldblatt in a small store on Chicago Avenue. However, in the 1970s, the chain started running into financial difficulties and eventually filed for bankruptcy. (Courtesy of the Conrad Sulzer Regional Library.)

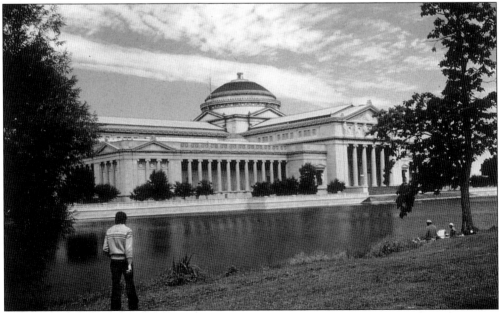

The Museum of Science and Industry in Jackson Park was founded in 1933 by Julius Rosenwald, who refused to have the Museum named after him. It occupies the restored Fine Arts Building of the World's Columbian Exposition of 1893. It is one of the finest science museums in the country and a major tourist attraction.

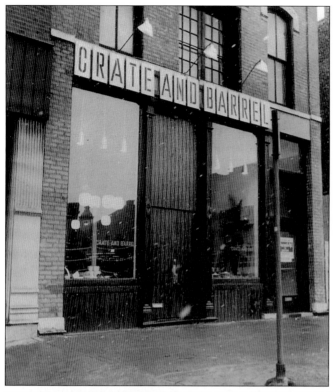

The first Crate and Barrel store was founded by Gordon and Carole Segal at Wells Street, south of North Avenue, in 1962. The contemporary housewares chain now has 85 stores all over the country. Gordon Segal is very active in community affairs and philanthropies. (Courtesy of Crate and Barrel.)

Joseph Gross (front right) is co-owner of the Chicago Hebrew Book Store on Devon Avenue, c. 1980s. Located on that same block is Rosenblum's Book Store.

Seven

ARTS AND ENTERTAINMENT

Through the years, countless Chicago Jews have been active in choral societies, orchestras, theater, artwork, sports, and literature. Some of the more prominent include Saul Bellow, Edna Ferber, Ben Hecht, and Meyer Levin in literature; Milton Horn, Todros Geller, and Aaron Bohrod in art; Benny Goodman, Mel Tormé, Fanny Bloomfield-Zeisler, and Mandy Patinkin in music; Barney Ross, Abe Saperstein, and Sid Luckman in sports; Shelly Berman, Morey Amsterdam, and Jack E. Leonard in comedy; and Florence Ziegfeld, David Mamet, Paul Muni, and Gene Siskel in the theater and movies. Jews also made significant financial contributions to the furthering of the arts and entertainment.

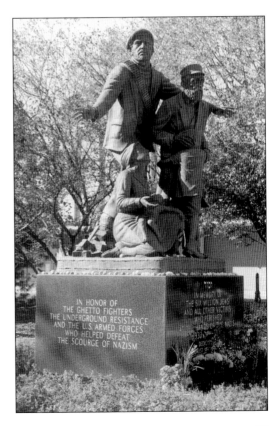

A Holocaust memorial was dedicated in 1987 opposite the Skokie Public Library in memory of the six million Jews and others who perished at the hands of the Nazis and in honor of those who fought against the Nazi regime. The sculpture by Edward Chesney was conceived and made possible by the Holocaust Survivors of Metropolitan Chicago with input and donations from many organizations and individuals. (Photo by Irving Cutler.)

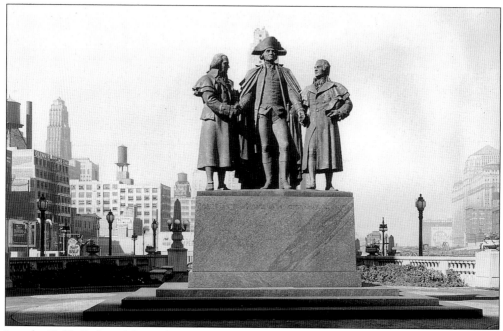

Lorado Taft's Robert Morris-George Washington-Haym Solomon monument is in Heald Square, Wacker Drive and Wabash Avenue. Dedicated on December 15, 1941, it symbolizes that people of all races and creeds helped build America from its very beginnings. To the right is Haym Solomon, a Polish-born, Jewish financier who underwrote sizable costs of the American Revolution.

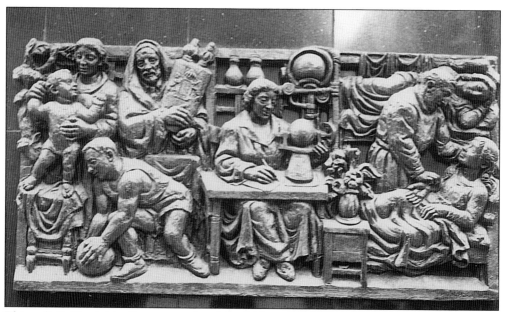

This relief, "Activities," was completed by Milton Horn in 1959 for the exterior of the headquarters of the Jewish Federation of Metropolitan Chicago at 1 South Franklin Street. It depicts the activities and concerns of the federation including the family, the young, the elderly, religion, education, as well as medical and legal aid. (Photo by Dr. Julius Wineberg.)

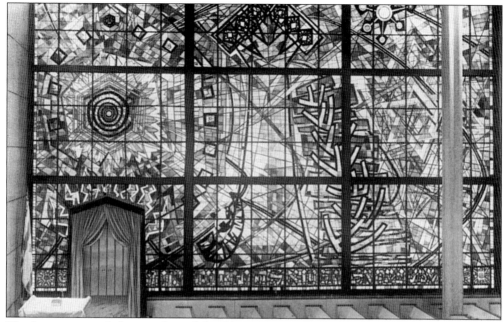

The famous stained glass window of the Chicago Loop Synagogue, designed by the American artist Abraham Rattner, uses glass fabricated in Paris and is an example of contemporary liturgical art. Installed in 1960, it is a design of ancient Hebrew symbols whirling through the cosmos. Among them are the Menorah, the 12 tribes, the burning bush, the star of David, the shofar, and a Hebrew prayer. The ark to the left holds the Torah scrolls and was designed by the Israeli sculptor Henry Azaz.

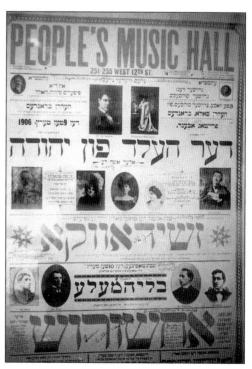

One of the earliest of the Yiddish theaters in the Maxwell Street area was the People's Music Hall on 12th Street (Roosevelt Road.) Shown on the billboard in 1906 are four plays. They are *The Hero from Judea, Jetovka, The Blossoming Tree,* and *Ashasuerus.*

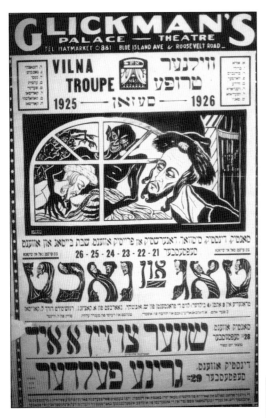

The largest of the Yiddish theaters in the Maxwell Street area was Glickman's Palace Theater on Blue Island and Roosevelt Road from 1919 to 1931, when it closed mainly due to the changing neighborhood and the Depression. The billboard shows their plays for the 1925–1926 season, when they featured the famous Vilna Troupe from Lithuania. The plays listed are *Day and Night, Hard to be a Jew,* and *The Green Fields.*

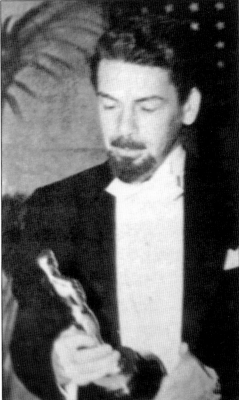

Paul Muni (Muni Weisenfreund, 1895–1967) played many different roles as a youngster in his father's Yiddish theater, the Weisenfreund Pavilion Theater, in the Maxwell Street area. He later went to Hollywood, where he became a noted and popular character actor winning an Academy Award for his performance in the movie *The Life of Louis Pasteur.*

The Douglas Park Auditorium at Ogden and Kedzie in Lawndale was a multipurpose Jewish institutional building. It housed the Workmen's Circle (Arbeiter Ring), Jewish labor unions, and the last full-season, Yiddish-speaking theater in the city from 1938 to 1951. (Photo by Irving Cutler.)

Pictured is a billboard for a Yiddish play at the Douglas Park Theater featuring the popular comedian Menasha Skulnik. Some of the top Yiddish stars performed there, including Molly Picon, Maurice Schwartz, Aaron Lebedoff, Dina Halpern, Michael Michalesko, Pesache Burstein, and Leon Fuchs. A young performer there named Bernard Schwartz went on to attain fame in Hollywood as Tony Curtis. (Courtesy of the American Jewish Historical Society.)

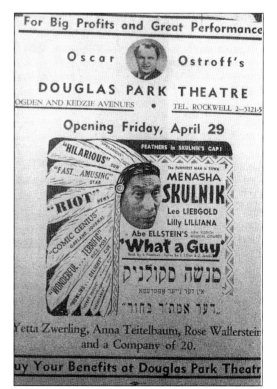

Dina Halpern (1910–1989) was a famous Yiddish actress in pre-World War II Poland. She later settled in Chicago, where she starred in many plays including some Yiddish Shakespeare. She married Danny Newman, the theatrical publicist.

Three prominent Jews who contributed to the cultural growth of Chicago are Hyman Resnick (left), longtime director of Halevy Choral Society; Ben Aronin (right), author, composer, and theatrical director; and Danny Newman (center), dean of theatrical publicists noted for his work with many theater and musical organizations. (Courtesy of the *Sentinel*.)

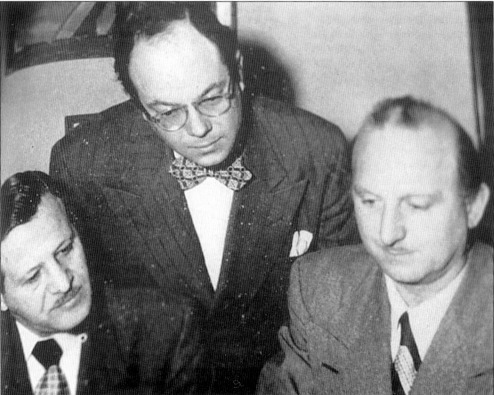

Freiheit Singing Verein, a singing group numbering about a hundred members, would meet weekly at the Chicago Hebrew Institute in the Maxwell Street area, 1923.

Halevy Choral Society performing to honor the memory of Cantor Moses J. Silverman (1914–1987) of Anshe Emet Synagogue. (Courtesy of the Chicago Jewish Archives.)

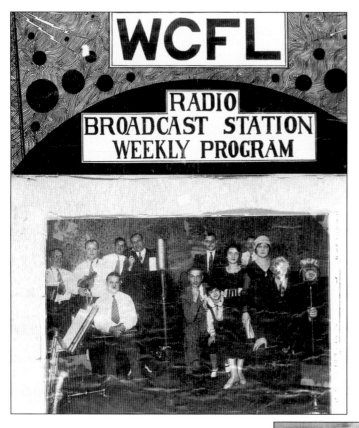

The Jewish Radio Hour was heard for years over radio station WCFL, "The Voice of Labor." There were a number of weekly *Yiddische Shtundes* (Yiddish Hours) heard also over radio stations WEDC and WSBC. The programs, interspersed with advertising of bargains at Jewish stores, featured music, comedy, and drama. This photo is of Hyman Novak with his band and actors. (Courtesy of David Rosen.)

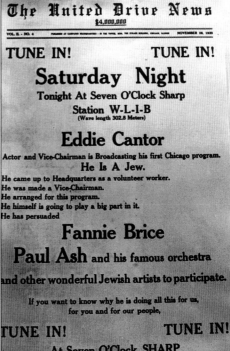

A pioneer radio broadcast in 1928 as a part of a Jewish fund drive featured Eddie Cantor, Fannie Brice, and the Paul Ash Orchestra.

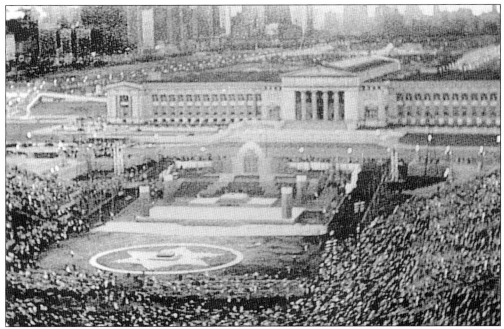

The pageant, "The Romance of a People" depicting highlights of Jewish history, was a major event of Jewish Day at Century of Progress World's Fair in 1933. The production included a cast of six thousand Jewish singers, dancers, and actors, attracting a capacity crowd of 125,000 people to Soldier Field. The guest speaker was Chaim Weizmann, who in 1948 became the first president of Israel. (Courtesy of *The Chicago Jewish News*.)

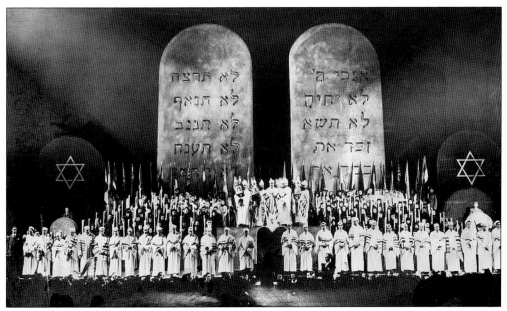

The pageant "We Shall Never Die" was written by Ben Hecht and performed to a capacity crowd in the Chicago Stadium on May 19, 1943. It exposed the slaughter of the Jews in Europe and called for vengeance and remembrance. The music was by Kurt Weill and the cast included John Garfield, Burgess Meredith, and Jacob Ben-Ami. (Courtesy of Janice Schurgin.)

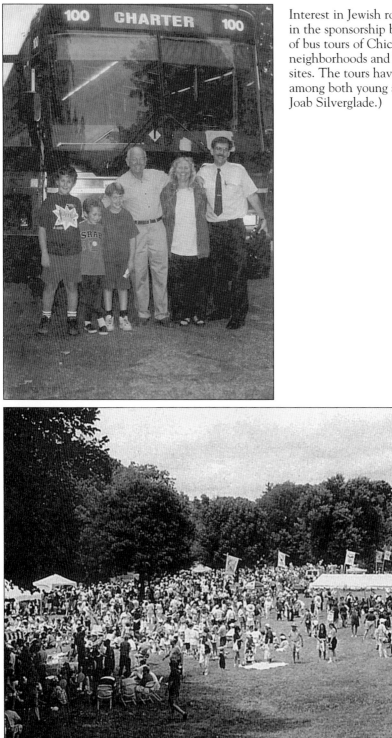

Interest in Jewish roots have resulted in the sponsorship by many groups of bus tours of Chicago Jewish neighborhoods and historic Jewish sites. The tours have proved popular among both young and old. (Photo by Joab Silverglade.)

The Greater Chicago Jewish Folks Art Festival attracted about 40,000 people in 1996. The festival is an annual event. (Courtesy of *The Chicago Jewish News*.)

The comedian Jack Benny (1894–1974) from Waukegan, the perennial 39-year-old tightwad, played the fiddle as a youth which later became one of his trademarks.

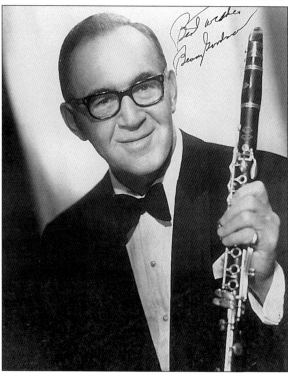

Benny Goodman (1909–1986), the King of Swing and a well-known clarinetist and band leader, was born in the Maxwell Street area and later lived in Lawndale. He performed before royalty, in Carnegie Hall, and famous composers wrote clarinet music dedicated to him. His was one of the first jazz ensembles in which both white and black musicians played together.

Studs Terkel, the well-known radio and television personality, is a famed author of a number of books based on taped interviews dealing with a wide variety of individuals and their remembrances of periods of stress. He was awarded the Pulitzer Prize for general non-fiction for his book *The Good War*, with recollections of the World War II period. (Courtesy of the Chicago Jewish Archives.)

Ann Landers is a popular, widely read advice columnist, as is her twin sister Abigail Van Buren. The "Bintel Brief" of the (Yiddish) *Jewish Daily Forward* was a forerunner of the Ann Landers type of advice column. (Courtesy of the Chicago Jewish Archives.)

Irv Kupcinet, raised in Lawndale, has been one of the city's most popular newspaper columnists for over 50 years. He has also been a professional football player and a television discussion program host and is still active in Jewish affairs. (Courtesy of the Chicago Jewish Archives.)

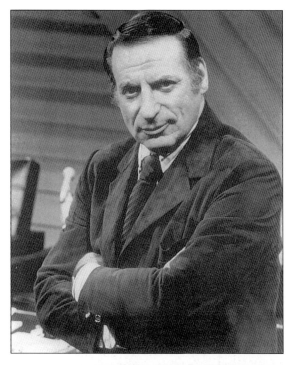

Saul Bellow, born in Quebec in 1915 but raised in Chicago's Northwest Side, is a leading figure in American and world literature, having received three National Book Awards, the Pulitzer Prize, and the Nobel Prize for Literature in 1976. (Courtesy of the Jewish Federation of Metropolitan Chicago.)

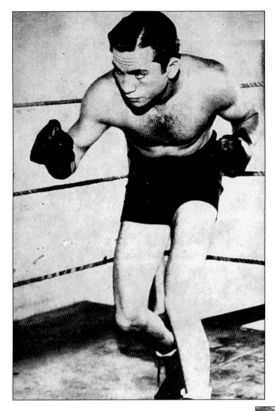

Barney Ross (1909–1967), raised in the Maxwell Street area, was a world boxing champion from 1933 to 1938. In World War II, he served heroically as a Marine on Guadacanal where he was wounded and contracted malaria as well as a drug habit that took years to cure.

Especially in the days before air conditioning and suburbia, Jews would often vacation during the summer in South Haven and Union Pier, Michigan and, to a lesser extent, the Indiana Dunes area. They would rent cottages or stay at Jewish resorts that were especially prevalent in South Haven, which at one time had some 55 resorts and boarding houses that could also be reached by daily boat service from Chicago in the summer. (Courtesy of the *Sentinel*.)

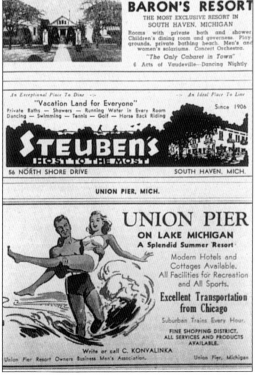

Eight

ORGANIZATIONS

Through the years, Jews formed literally thousands of organizations of various types. These included about seven hundred landmanshaften or vereins (organizations of immigrants from the same European community). In addition, there were organizations involved with education, religion, political beliefs, Zionism, social services, sports, youth, the elderly, women's issues, camping, veterans, community services, and social, fraternal, and recreational activities. Each sizable Jewish community had many of these organizations. This chapter will provide images of a few of them.

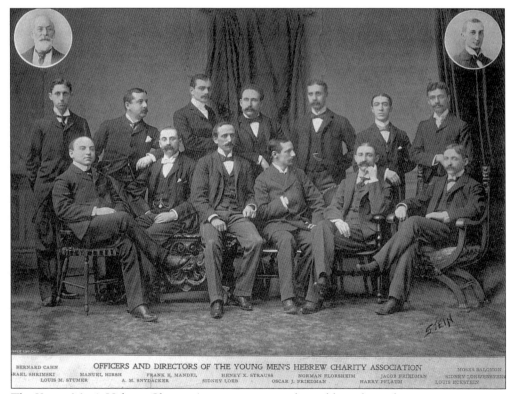

The Young Men's Hebrew Charity Association was a charitable and social service organization, *c.* 1896. Its membership consisted of established German Jews.

This photo was taken at the 1905 convention in Chicago of the Order Knights of Zion (later, the Zionist Organization of Chicago). In front, left to right, are Dr. H. Lyman, a close friend of Theodore Herzl, and Dr. Alexander Wolfe, a leading St. Louis Zionist. In back, left to right, are four early active Chicago Zionists: Judge Philip P. Bregstone, Judge Harry M. Fisher, Nathan P. Kaplan, and author and journalist S.B. Komaiko. (Courtesy of the *Sentinel*.)

At an early meeting of Hadassah in 1926 Chicago honors British Field Marshall Allenby (tall man in center). Four prominent Hadassah leaders are present. Pearl Franklin is in the front row and, left to right in the rear are Hannah G. Solomon, Mrs. Bertha Read Rissman, and Mrs. Harry Berkman. Hadassah provides medical, social, and other services to Israel. (Courtesy of the *Sentinel*.)

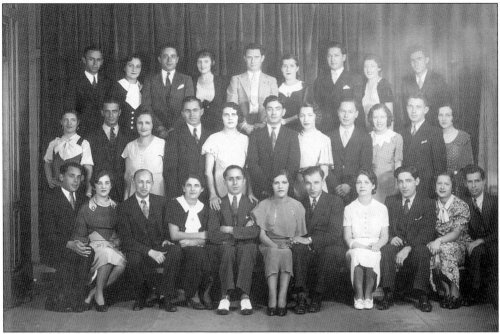

Some in this 1932 photo of the Borochov Branch of the Poale Zion (Labor Zionists) later settled in Israel. (Courtesy of Rose Pollack.)

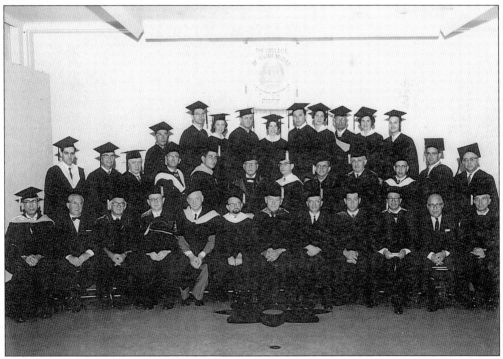

Photographed above are graduates of the College of Jewish Studies at 72 East 11th Street in 1961. It is now the Spertus Institute of Jewish Studies located at 618 South Michigan Avenue. (Courtesy of the Chicago Jewish Archives.)

This is the construction of the third clubhouse of the Standard Club, 1926. Founded in 1869 by German Jews, it served mainly as a social and recreational gathering place. Later, it also became active in community and civic affairs and supported many worthy causes. (Courtesy of the Standard Club.)

Pictured is a *c.* 1940s fashion show at the Standard Club. (Courtesy of the Standard Club.)

Pictured is the May 27, 1935 dinner menu at the Standard Club. (Courtesy of the Standard Club.)

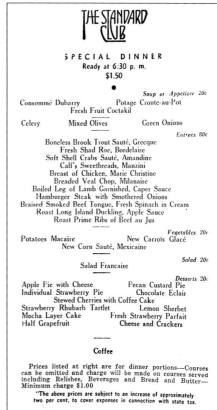

THE STANDARD CLUB

SPECIAL DINNER
Ready at 6:30 p. m.
$1.50

●

Soup or Appetizer 20c

Consommé Dubarry Potage Croute-au-Pot
Fresh Fruit Coctakil

Celery Mixed Olives Green Onions

Entrees 80c

Boneless Brook Trout Sauté, Grecque
Fresh Shad Roe, Bordelaise
Soft Shell Crabs Sauté, Amandine
Calf's Sweetbreads, Manzini
Breast of Chicken, Marie Christine
Breaded Veal Chop, Milanaise
Boiled Leg of Lamb Garnished, Caper Sauce
Hamburger Steak with Smothered Onions
Braised Smoked Beef Tongue, Fresh Spinach in Cream
Roast Long Island Duckling, Apple Sauce
Roast Prime Ribs of Beef au Jus

Vegetables 20c

Potatoes Macaire New Carrots Glacé
New Corn Sauté, Mexicaine

Salad 20c

Salad Francaise

Desserts 20c

Apple Pie with Cheese Pecan Custard Pie
Individual Strawberry Pie Chocolate Eclair
Stewed Cherries with Coffee Cake
Strawberry Rhubarb Tartlet Lemon Sherbet
Mocha Layer Cake Fresh Strawberry Parfait
Half Grapefruit Cheese and Crackers

Coffee

Prices listed at right are for dinner portions—Courses can be omitted and charge will be made on courses served including Relishes, Beverages and Bread and Butter—Minimum charge $1.00
"The above prices are subject to an increase of approximately two per cent, to cover expenses in connection with state tax.

Monday, May 27, 1935

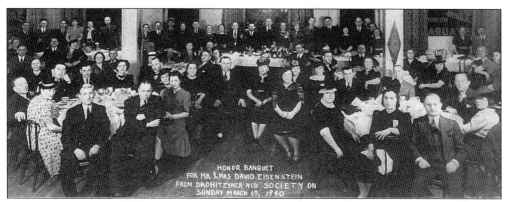

A 1940 banquet of the Drohitzyner Aid Society, an organization that was one of hundreds of such vereins or landsmanshaften in Chicago composed usually of people from the same community in the Old Country. They provided help, safety, and security in a new alien world, as well as places for social interaction and communication. They also tried to help those still remaining in their community in the Old Country. (Courtesy of Sidney Sorkin.)

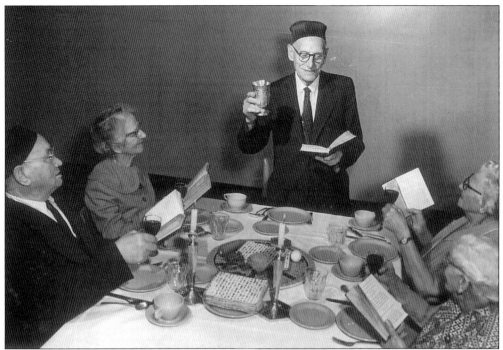

Residents of the Drexel Home for the Aged, at 62nd Street and Drexel Avenue, celebrate a Passover Seder, c. 1960s. The home was founded in 1893 and its earliest residents were primarily German Jews. It closed in 1981. (Courtesy of the Chicago Jewish Archives.)

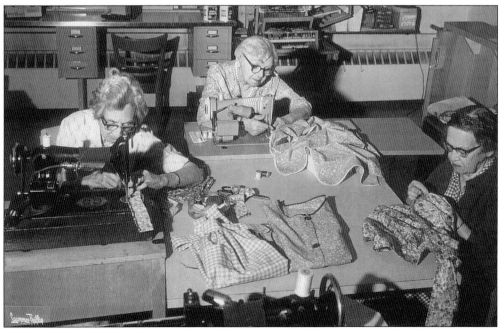

Women sewing at the Drexel Home for the Aged, 1967. (Courtesy of the Chicago Jewish Archives.)

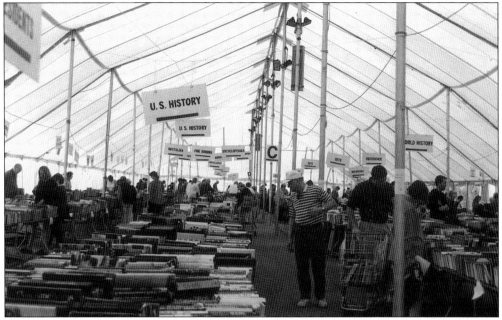

The annual Brandeis Used Book Sale, held at the Old Orchard Shopping Center in Skokie, 1999, is said to be the largest used book sale in the country. It is run by the North Shore Chapter of the Brandeis University National Women's Committee and is a fund raising event for Brandeis University libraries. (Photo by Irving Cutler.)

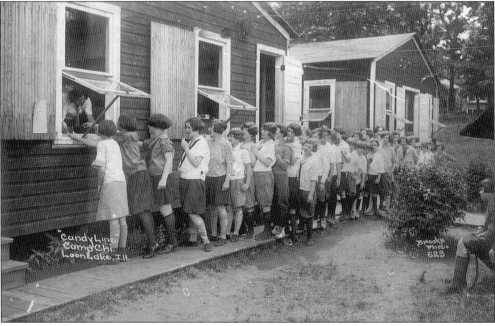

Girl campers lining up for a candy treat at Camp Chi, run by the Jewish Community Centers, c. 1930. Chi is an acronym for the Chicago Hebrew Institute which was the first major Jewish Community Center located at Taylor and Lytle Streets from 1908 to 1926. The camp is now located at Lake Delton, Wisconsin. (Courtesy of the Jewish Community Centers.)

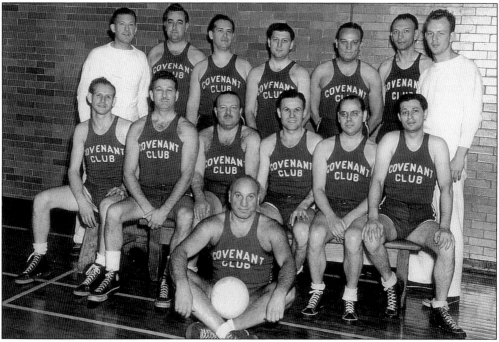

Covenant Club members participating in a volleyball tournament, 1947. The club was founded in 1917 and, in the 1920s, it built an 11-story building at 10 North Dearborn Street. It served as a private social, recreational, and cultural club and engaged in many worthy community activities. Most of its members were of Eastern European descent. The club disbanded in 1986. (Courtesy of the Chicago Jewish Archives.)

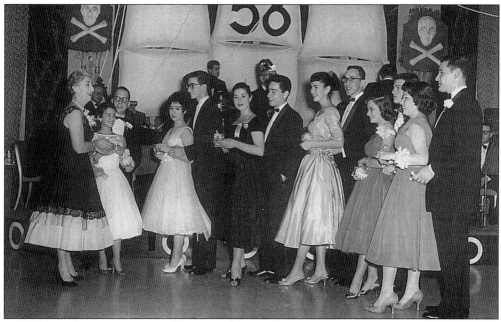

Sons and daughters are pictured here attending a formal ball on December 28, 1957, at the Covenant Club. (Courtesy of the Chicago Jewish Archives.)

Pictured left to right in the 1957 Covenant Club program "Silhouette of Yesteryear" are Mrs. Maury Katzenberg, Mrs. Samuel Baskin, Mrs. Al Schwartz, and Mrs. Jack Frank. (Courtesy of the Chicago Jewish Archives.)

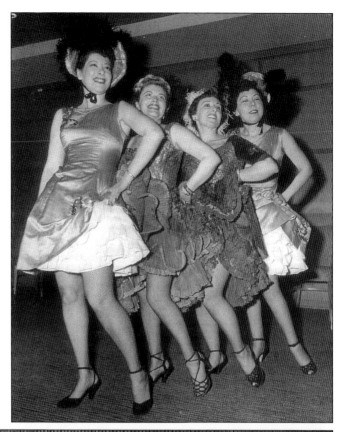

Older boys giving haircuts to younger boys at the Marks Nathan Jewish Orphan Home located on Albany Avenue near 16th Street opposite Douglas Park in Lawndale from 1912 to 1948. It took good care of the three hundred boys and girls it was equipped to handle. (Courtesy of the Jewish Federation of Metropolitan Chicago.)

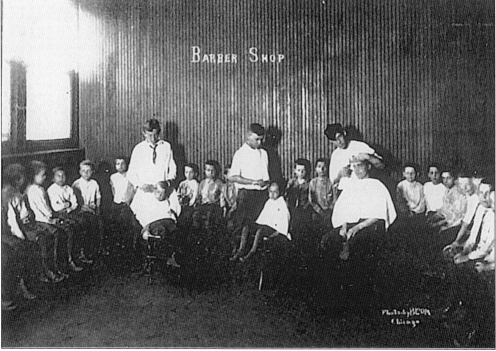

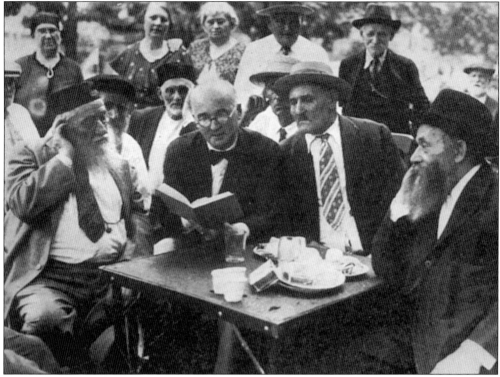

S.B. Komaiko reads from his book of Yiddish short stories to the residents of the Orthodox Jewish Home for the Aged (Beth Moshav Z'Keinim) in 1910. The facility was located at 1648 South Albany Avenue, opposite Douglas Park in Lawndale. (Courtesy of the *Sentinel*.)

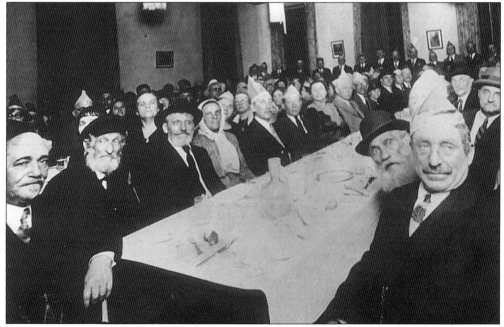

A banquet held for the residents of the Orthodox Jewish Home for the Aged, 1926.

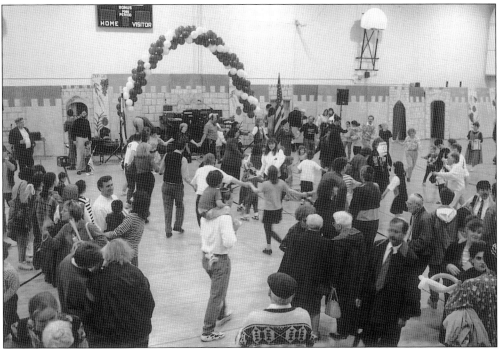

Some 1,200 Jews of all ages attended a recent celebration of Yom Ha'Atzmaut (Israel Independence Day) at the Bernard Horwich Jewish Community Center. The celebration was sponsored by various Jewish organizations and consisted of music, dancing, shows, and kosher food. (Courtesy of *The Chicago Jewish News*.)

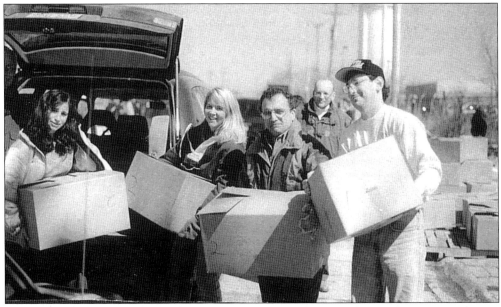

The Moes Chitim workers distribute Passover food packages to the needy, to recent Russian immigrants, some elderly, and others in this annual event involving the work of hundreds of volunteers. (Courtesy of *The Chicago Jewish News*.)

The Hebrew clock of the Israeli Bank Leumi located at the corner of Washington Boulevard and LaSalle Street. (Courtesy of *The Chicago Jewish News*.)

Taken in 1999, this photo shows the new Bernard Weinger Jewish Community Center in Northbrook, located in a suburban area of current rapid Jewish growth. It is one of nine such centers in the Chicago area. Their purpose is to enhance and maintain Jewish life through educational, cultural, social, and recreational programs. (Photo by Irving Cutler.)

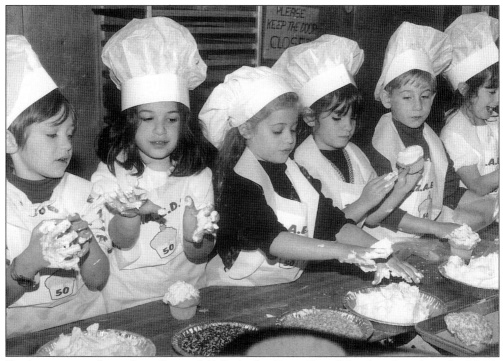

Kindergarten students from Bernard Zell Anshe Emet Day School gathered at the North Shore Bakery in Chicago to bake and frost dozens of cupcakes to celebrate their school's 50th Anniversary in 1996. From left to right are Alex Gaynor, Madeline Holland, Sarah Berman, Gabi Kaminsky, David Topel, and Lexi Kraft. (Courtesy of *The Chicago Jewish News*.)

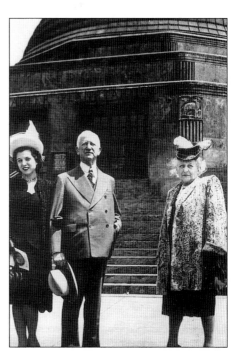

Max Adler, an executive with Sears, Roebuck, and Company with his wife (right) and daughter-in-law in front of the Adler Planetarium, which he endowed in 1930. A concert violinist, he also helped many young men and women in their musical careers, including Isaac Stern.

The Council for Jewish Elderly is an umbrella organization created by the Jewish Federation of Metropolitan Chicago to continue the Jewish tradition of taking good care of the aged. The Council has a fleet of wheelchair accessible buses to take seniors to doctors, shopping, or to other prearranged destinations. (Courtesy of the Jewish Federation of Metropolitan Chicago.)

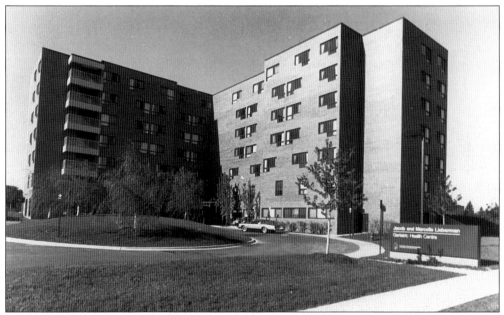

The Lieberman Geriatric Health Center of the Council of Jewish Elderly in Skokie is an example of the recent emphasis on housing for the elderly in the form of assisted living. The facility features private rooms and community services, such as a synagogue, a health center, beauty shop, craft center, and a library. (Courtesy of the Council of Jewish Elderly.)

Nine

RELIGION

In Chicago today, there is a great diversity of religious Judaism, ranging from the religious fervor of the Lubavitch Hasidim to the humanistic Reform congregation. The first synagogue was organized in 1847. Over a century and a half later, there are about 120 synagogues and three Orthodox yeshivahs. The synagogues reflect the differing backgrounds and beliefs of their people. German Jews, as they moved outward, built many imposing synagogues that very early became part of the Reform Movement. The Eastern European Jews built some 40 Orthodox synagogues, some very small, in the Maxwell Street area. As they moved to Lawndale, they built some 60 Orthodox synagogues there, many built by people from the same European town or country and carrying its name. In neighborhoods further out, like Humboldt Park, Logan Square, Albany Park, and Rogers Park, there was a mixture of Reform, Conservative, and Orthodox synagogues. Today, West Rogers Park is the bastion of Orthodoxy in the city. As one moves into the suburbs, there is generally a dominance of Conservative and Reform congregations interspersed with some Orthodox, Reconstrictionist and Lubavitich congregations. With numerous alternate institutions and attractions and the dispersal of Jews outward, the synagogues do not play as prominent a role as in the past and slightly more than half of Jewish families are not currently affiliated with a synagogue. However, as soon as there are enough Jews in the area, one of the first institutions organized is a synagogue, and it is what often holds them together.

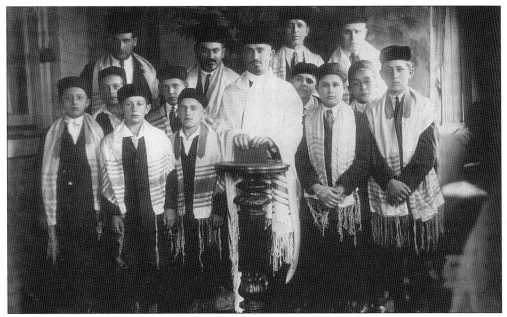

The High Holiday choir at the Kehillat Jacob Congregation located at Hamlin and Douglas Boulevard in Lawndale, 1930. The congregation is now on Devon Avenue in the West Rogers Park area. (Courtesy of the Chicago Jewish Archives.)

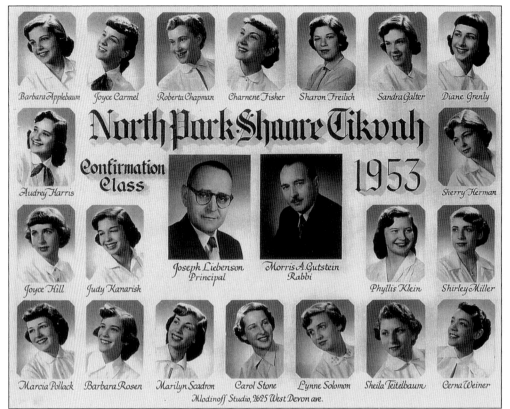

The rabbi of the North Park Shaare Tikvah (now Shaare Tikvah) was Rabbi Morris A. Gustein, the author of a number of Jewish history books, including *A Priceless Heritage* (1953), about the Jews of Chicago. Shaare Tikvah is located in North Park at 5800 North Kimball Avenue. (Courtesy of the Chicago Jewish Archives.)

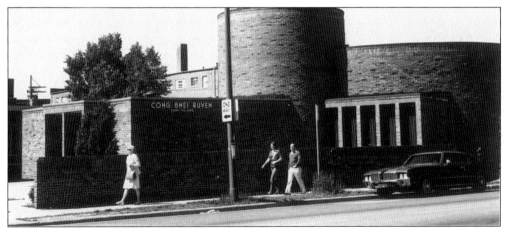

B'nai Reuven at Devon and Whipple Avenues in West Rogers Park is a Lubavitch Chassidic synagogue and is more than a century old. Like many synagogues, it started in the Maxwell Street area, moved to Lawndale, and now is in West Rogers Park. A part of its present award-winning building, constructed in 1967–1968 resembles a Torah scroll on the outside and contains the Torah scrolls on the inside. (Photo by Irving Cutler.)

Sheldon Robinson (left), sponsor of a new Torah with the centenarian Rabbi Adolph and Rabbi Nathan, a Torah scribe, are shown completing the Torah scrolls on October 24, 1989.

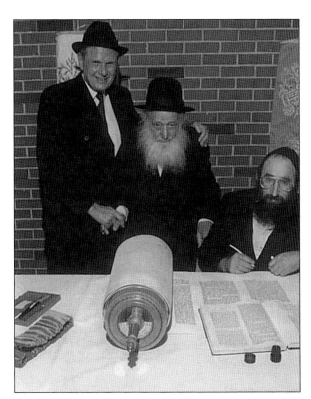

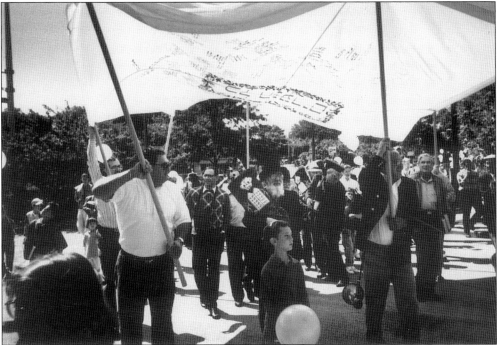

The Torahs of Congregation Or Torah are being moved in 1993 to their new home at 3800 West Dempster in Skokie. Rabbi Gedalia Schwartz, *dayan* (chief justice) of the Rabbinical Council of America, is shown carrying the Torah. (Photo by Irving Cutler.)

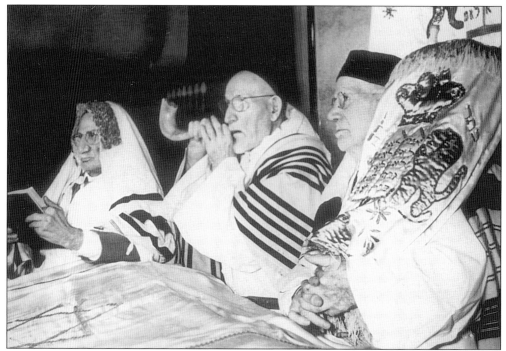

Shofar blowing at High Holiday services at the Orthodox Jewish Home of the Aged, *c.* 1925.

Students Cory Nanus and Ezra Forman working at a computer in 1995 at the Solomon Schechter Day School in Skokie. (Courtesy of *The Chicago Jewish News.*)

The third graders at the Rosenwald Jewish School in Chicago, from left to right, are Camilo Pedro, Masha Izakson, Daphna Rosen, Anna Shvedchenko, Sasha Yevdokimova, David Denker, Philip Kostov, Moriah Aberman, and Daniel Rebecchi. The school closed in 1999. (Courtesy of *The Chicago Jewish News*.)

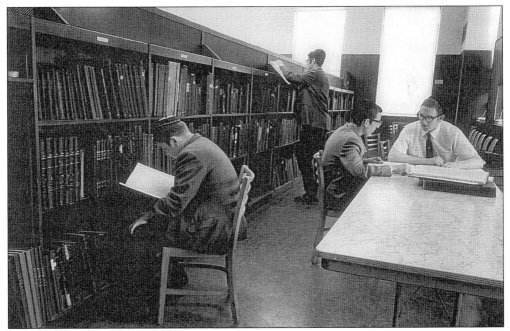

Students study in the library at the Telshe Yeshivah, located at Foster and Drake Avenues. The Orthodox Yeshivah's roots go back to the renowned Telshe Yeshivah in Telshe, Lithuania which was wiped out by the Nazis and later reestablished in Cleveland by a few who escaped. This branch was established in Chicago in 1960. It has about 150 students from across the country in its high school, college, and graduate school levels. (Courtesy of the Chicago Jewish Archives.)

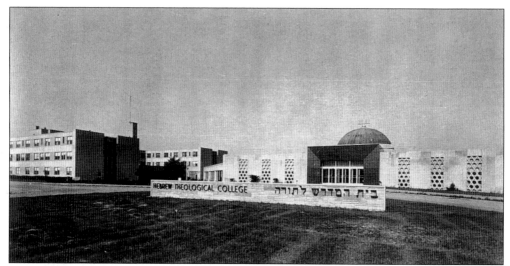

The Hebrew Theological College moved from Lawndale to the present site at 7135 North Carpenter Road in Skokie. Through the years it has ordained over five hundred Orthodox rabbis, and thousands of others have attended its ancillary institutions. (Courtesy of the Chicago Jewish Archives.)

Students assemble in the lecture hall of the old Hebrew Theological College in Lawndale to hear Rabbi Chaim Zvi Halevi Rubenstein in 1942. (Courtesy of the Hebrew Theological College.)

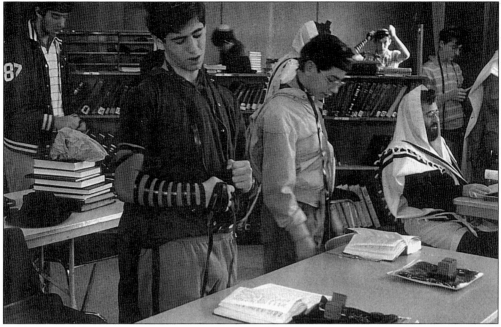

Students and faculty of the Hebrew Theological College in Skokie are at morning prayer services. (Courtesy of the Hebrew Theological College.)

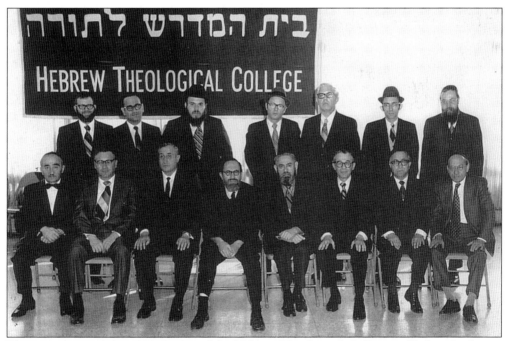

This is a photo of the 1972 faculty of the Hebrew Theological College in Skokie. Back row, from left to right, are Rabbis Yitzchok Giffin, Howard Weine, Moshe Bernstein, Yitchak Sender, Bertham Schwartz, unidentified, and Gedalia Rabinowitz. Front row, from left to right, are Hirsch Isendberg, Paul Greenman, Josef Leff, Aaron Soleveitchik, David Silver, Harold Smith, Eliezer Gottlieb, and Herzl Kaplan. (Courtesy of the Hebrew Theological College.)

The sins of a person are symbolically transferred to a fowl as it is swung around the head is the ancient custom of Schlogging Kapporoth on the day before Yom Kippur Eve. The fowl is later donated to the poor. Almost all observant Jews use money today instead of fowl, donating money to charity.

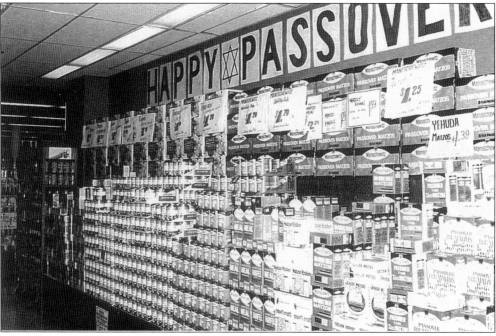

An early Dominick's food store featuring Passover foods. Today, Jewish foods are a staple in many large supermarkets. (Courtesy of the Chicago Jewish Archives.)

A *sukkah* has been attached to the Great Chicago Food and Beverage Company restaurant at Devon and Kedzie Avenues. A *sukkah* is a temporary religious shelter to eat in during the Sukkoth holiday period. (Photo by Irving Cutler.)

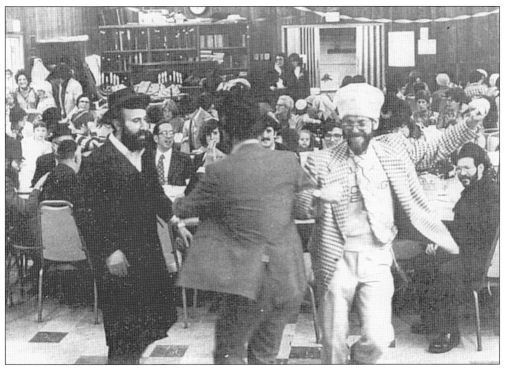

Purim is being celebrated at the Yeshiva Migdal Torah Jewish Learning Center in West Rogers Park, 1983.

The Jewish Waldheim Cemetery in Forest Park is the largest Jewish cemetery in the Chicago area with about 175,000 graves. The over a century old cemetery is divided into nearly three hundred separate sections representing congregations, lodges, family circles, fraternal organizations, and landsmanshaften. Inscriptions are in English, Yiddish, Hebrew, German, and even Portuguese and Ladino. (Courtesy of *The Chicago Jewish News*.)

A number of memorial monuments are found in the area's Jewish cemeteries, including this monument at the Jewish Waldheim Cemetery in memory of those killed by the Nazis in the town of Motele, Poland, in 1942. (Courtesy of Irwin Lapping.)

Shown is the vandalism at the Mt. Mayriv Cemetery, 1996. It is a Jewish cemetery at 3600 North Narrangansett Avenue in Chicago. (Courtesy of *The Chicago Jewish News*.)

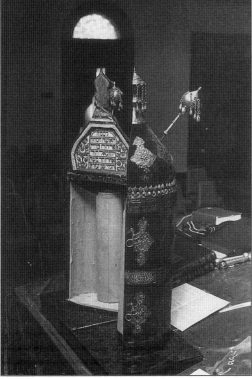

A Torah case at the Sephardic Congregation located at 1819 West Howard Street in Evanston where Rabbi Michael Azoze is the spiritual leader. Sephardic Jews came from areas in the Mediterranean basin. They differ from the Ashkenazi Jews of Central and Eastern Europe in background, language, and some religious practices. There are three Sephardic synagogues in the Chicago area. (Courtesy of Joe Kus and *The Chicago Jewish News*.)

Temple Anshe Sholom in Olympic Fields, a Reform congregation with a membership of over five hundred families, is the largest congregation in the southern suburbs. (Photo by Irving Cutler.)

North Suburban Synagogue Beth El was founded in the late 1940s to serve the growing Conservative Jewish population of the North Shore. The building was designed by Percival Goodman and incorporates the original mansion on its lakefront site at 1175 Sheridan Road in Highland Park. It is noted for its art work and rotating exhibits of Jewish interest. Its spiritual leader is Rabbi Vernon Kurtz. (Photo by Dan Cutler.)

Chicago Sinai Congregation, founded in 1861 as the city's first Reform congregation, recently moved into its new home at 15 West Delaware Place on the Near North Side after being located at a number of South Side sites for over a century. The new location is in line with the residential trend of its membership. (Photo by Dr. Julius Wineberg,.)

Founded in 1972, the Reform congregation Temple Chai in the Long Grove/Buffalo Grove area had previously met in an office building on Dundee Road. Pictured is its 1980 construction. (Photo by Irving Cutler.)

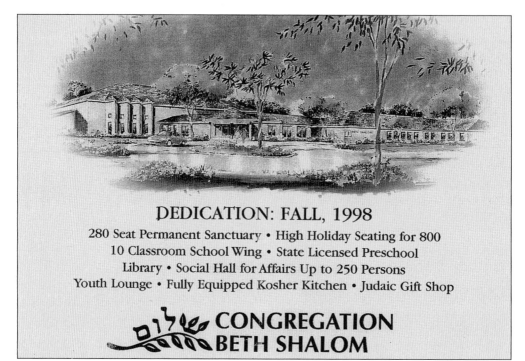

DEDICATION: FALL, 1998

280 Seat Permanent Sanctuary • High Holiday Seating for 800
10 Classroom School Wing • State Licensed Preschool
Library • Social Hall for Affairs Up to 250 Persons
Youth Lounge • Fully Equipped Kosher Kitchen • Judaic Gift Shop

שלום CONGREGATION BETH SHALOM

This announcement is for a large new synagogue completed in 1998 for the Reconstructionist Congregation Beth Shalom in Naperville. Started as a religious school in the mid-1970s, the ensuing congregation soon outgrew its earlier facilities as the area experienced an influx of young Jewish professionals employed in the rapidly growing high-tech research facilities in this western suburban area. (Courtesy of Congregation Beth Shalom.)

This first service of the new Congregation Tikkun Olam was held in McHenry County in Woodstock, Illinois, 52 miles northwest of Chicago, on Friday night, August 30, 1996 in the home of Gerry and Emily Berendt. From left to right are Bonnie Pashkow, Nelson Dunitz saying the *Ha'motzi*, Gerry Berendt, and Emily Berendt. Spreading commercial and industrial facilities, lower real estate costs, and improved transportation have enabled people to move farther out from Chicago. And when there are enough Jews in a new area they begin to organize Jewish institutions. (Courtesy of Gerry Berendt.)